This book
belongs to:

grandma Hoig

hoper y Moyo

flower power

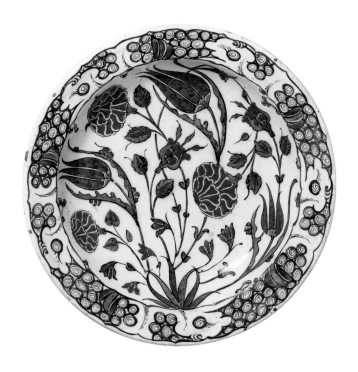

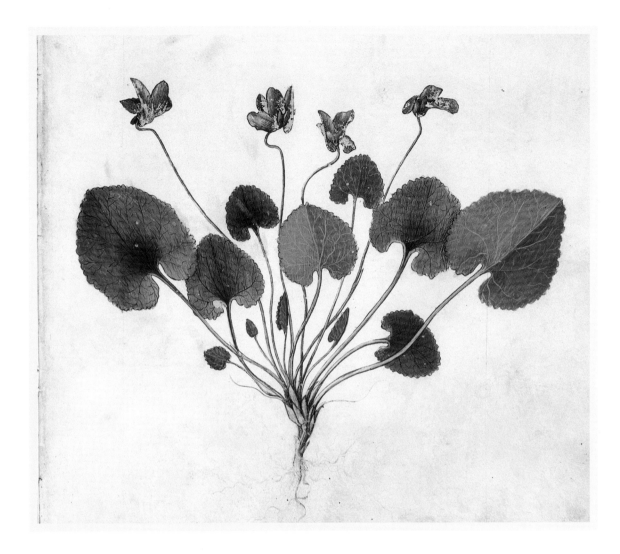

Violet (Viola odorata) from The Carrara Herbal

Serapione Herbario Volgare, Padua, 1390s

Gouache on vellum

The British Library

This image of a violet is one of a number of finely designed and coloured drawings of plants that illustrate an Italian version of the treatise on medical botany by the Arab physician, Serapion the Younger (c. 800). This important Venetian manuscript, once owned by Francesco Carrara, Lord of Padua (died 1406), is known as the Carrara Herbal. This subtly realistic study by an unknown artist of the humble violet, conveys an early naturalism. The violet at this period symbolized humility and modesty, qualities associated with the Virgin Mary. In medical botany, the herbal qualities associated with the violet are mainly in the treatment of congestive pulmonary and sensitive skin conditions.

Although floral motifs as decoration can be traced back to the paleolithic era, the earliest known florilegium, or flower anthology, is found in a series of two hundred and seventy-five plants carved as limestone *bas-reliefs* on the walls of the Great Temple of Tuthmosis III at Karnak in Egypt. These date from the fifteenth century BC and apart from a small fragment of a herbal known as the Johnson Papyrus (about 400 AD) have no surviving equivalent until the famous Vienna codex (about 512 AD) of Dioscorides' great work, *De Materia Medica* (the first century AD). Medieval herbals represent the earliest anthologies of flowers in the modern period.

flower power

The Meaning of Flowers in Art

With an Introduction by Anna Pavord

Edited by Andrew Moore and Christopher Garibaldi

NORFOLK Museums
& Archaeology Service

PWP
PHILIP
WILSON
PUBLISHERS

Sheffield Galleries
& Museums Trust

First published in 2003 by Philip Wilson Publishers,
7 Deane House, 27 Greenwood Place, London NW5 1LB

Distributed by I. B. Tauris & Co. Ltd, 6 Salem Road, London W2 4BU

Distributed in the USA and Canada by Palgrave Macmillan,
175 Fifth Avenue, New York, NY 10010

Introduction by Anna Pavord
Editors: Andrew Moore and Christopher Garibaldi

Contributors
Dorian Church, Curator of Decorative Art
Sheffield Galleries & Museums Trust
Anne Goodchild, Curator of Fine Art
Sheffield Galleries & Museums Trust
Jane Knowles, Assistant Curator
Norwich Castle Museum & Art Gallery
Rachel Woodruff, Assistant Curator
Sheffield Galleries & Museums Trust

Designer: Peter Ling
Printed in Italy by EBS, Verona

© Norfolk Museums & Archaeology Service and Sheffield Galleries and Museums Trust

ISBN (hardback) 0 85667 573 3
ISBN (softback) 0 90310 173 4

Contents

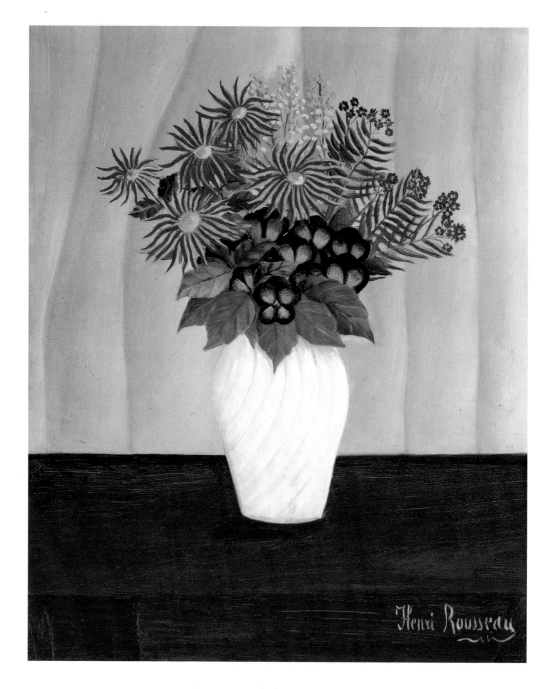

Bouquet of Flowers 1909-10

Henri Rousseau 1844–1910
Oil on canvas 61 x 49.5 cm
Tate, London

Rousseau was an untutored painter who once worked as a Customs official. His fresh approach to painting led to him being much admired by the Parisian avant-garde before the First World War. His flower paintings achieve a magical and exotic air, with a harmony of tone and exquisite precision derived from direct observation. The power of Rousseau's image to move us results from his formal control, with no attempt at symbolism.

Foreword

This book is about the power of cut flowers to move the onlooker. This power to move has been crucial to the adoption of flowers in every culture to symbolize life, beauty and death. All religions have flowers at the heart of their faith. Art has proved an enduring companion in the representation of the power of flowers to move.

The book brings together a wide variety of ravishing illustrations of the cut flower in the history of European fine and decorative art since 1500. It explains their symbolic meanings and demonstrates the response that flowers evoke in us all. The representation of non-European traditions at certain points, such as those of China and the Indian sub-continent, enriches the visual material and illustrates the differences and commonality between faiths and cultures.

The series of thematic chapters feature works of fine and decorative art, books and manuscripts. The early symbolism and mythologies associated with flowers is illustrated including important emblematic themes such as Death and the Resurrection (Narcissus); Dynastic meanings (Rose); Transience and Vanity (Rose); the Immaculate Conception and Purity (Lily); Devotion, Pride, Rulers and Vitality (Sunflower). Illustrations of paintings, textiles, furniture, silver and ceramics focus on individual flowers through the course of the book.

Conceived as a companion to the exhibition *Flower Power* (Norwich and Sheffield, February-August 2003), the book acts as an appealing introduction to a subject which deserves a wide readership.

Neil MacGregor
Director, The British Museum

Sponsor's Foreword

When we launched Sainsbury's Art to You, our aim was to help regional art galleries meet the challenges of attracting a new and wider range of visitors, introducing them to imaginative and innovative exhibitions with broad appeal. We were also keen to bring great art to our customers' doorstep. We are delighted that our support of Norwich Castle Museum and Art Gallery and Sheffield Millennium Galleries has resulted in *Flower Power*, an exhibition of tremendous quality and interest whose reach is being extended further through this accompanying book.

Sainsbury's Art to You is part of a comprehensive community programme that focuses on a variety of projects ranging from Sainsbury's Choir of the Year to support for Comic Relief. In 2001/02, this programme was responsible for some £11m being donated through community, in-kind and sponsorship programmes across the UK.

We feel that *Flower Power* is a valuable addition to that tradition and hope the exhibition and book will bring enjoyment and enlightenment to all who see them.

Sir Peter Davis
Group Chief Executive, J Sainsbury plc

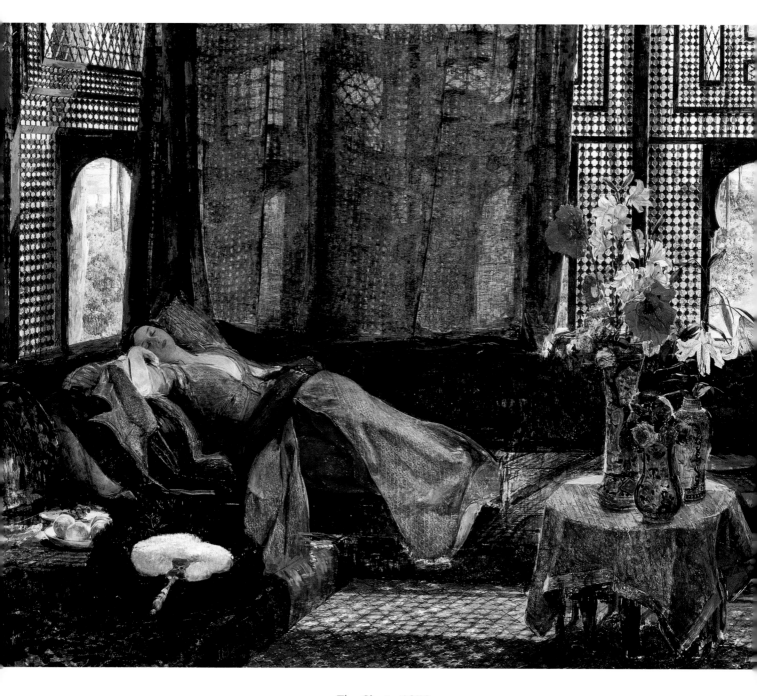

The Siesta 1876

John Frederick Lewis 1805–76
Oil on canvas, 88.6 x 111.1 cm
Tate, London

John Frederick Lewis is notable for having settled in Cairo in 1841 for a period of ten years. From 1841 he did not exhibit in London, but caused a sensation in 1850 with his watercolour *The Hareem*. He proceeded to earn a reputation for his Orientalist subjects, usually of the Near East, painted in both oils and watercolour. He achieved great attention to detail and remarkable effects of light and colour. Here the reclining figure of a woman in a Hareem is given typically western features, while the languid, opiate atmosphere is enhanced by the group of three Imari vases of exotic flowers, which feature the poppy, keynote symbol of opiate luxury.

Acknowledgements

This book is published to coincide with the exhibition, *Flower Power* (Norwich Castle Museum & Art Gallery, 3 February – 5 May 2003 and The Millennium Galleries, Sheffield, 24 May – 25 August 2003). Organized jointly by Norfolk Museums and Archaeology Service and Sheffield Galleries & Museums Trust the project won the 'Sainsbury's Art to You' award for a regional touring exhibition proposal. The partners wish to record their gratitude to Sainsbury's for this unique opportunity for a regional museum project to achieve full funding from its inception. The project team particularly wishes to thank Kallaway Ltd for their agency on behalf of Sainsbury's and the partners.

This book would also not have been possible without the support of the lenders to the exhibition. Although not all loans to the show are illustrated within this book it is important to record that it is their gen-erosity which is at the heart of the original research that has been undertaken in order to present an original view of the history of flowers in art. We particularly wish to thank His Grace the Duke of Westminster; His Grace the Duke of Buccleuch & Queensbury; His Grace the Duke of Devonshire; The Marquise of Lansdowne; Lady Victoria Leatham; the Ashmolean Museum of Art & Archaeology, Oxford; the Bowes Museum, Barnard Castle; The British Library; The British Museum; Claire Curneen; Thomas Dane Ltd.; Dulwich Picture Gallery; Eton College Library; English Heritage; Frans Halsmuseum, Haarlem; Mr Colin Hanley; Houldsworth; Jersey Heritage Trust; the John Innes Centre, Norwich; Rob Kesseler; Lehmann Maupin Gallery, New York; Philip Mould (Historical Portraits Ltd); the National Gallery, London; the National Gallery of Scotland, Edinburgh; the National Maritime Museum, London; the National Museum of Wales, Cardiff; the National Portrait Gallery, London; the National Trust; the Royal Museum of Scotland; Richard Slee; Southampton City Art Gallery; Tate; the Victoria & Albert Museum; White Cube. In addition, we thank the public and private owners who have generously given permission for their works of art to be illustrated in this publication, including those who wish to remain anonymous.

We are also grateful to a number of individuals who have provided support and expertise. We particularly wish to thank Carla Lathe who undertook much of the initial research into the history of the meaning of flowers on behalf of the contributing authors: the assessments of symbolism in individual images is founded upon her admirable work. We are also indebted to Kenneth Beckett for his expert botanical advice in helping to identify species of flowers represented in individual works of art and commenting upon the degrees of artistic license to be found in certain works. We are especially grateful to Anna Pavord for contributing the introduction, which extends the interest of the book for the reader in a way that deftly traces our passion for the cut flower as it relates to the history of British and European art.

We and our fellow contributors, Dorian Church, Anne Goodchild and Rachel Woodruff of Sheffield Galleries & Museums Trust and Jane Knowles of Norwich Castle Museum & Art Gallery, would like to record our joint thanks to the following people who have helped us in the preparation of this publication: Gaye Blake Roberts, Judith Crouch, Jon Culverhouse, Peter Day, Heather Guthrie, Tony Irwin, Joanne Kidd, Caroline Krzesinska, Scot McKendrick, Sir Oliver Millar, Rebecca Milner, Graham Padett, Miranda Percival, Sonnet Stanfill, Tim Stanley, Elizabeth Stratton, Emma Taylor, Martin Webb, Mark Weiss, Liz Williamson and Emma Woods. Finally, we would like to express our appreciation of Anne Jackson, Peter Ling, and the publishing team at Philip Wilson.

Andrew Moore
Christopher Garibaldi

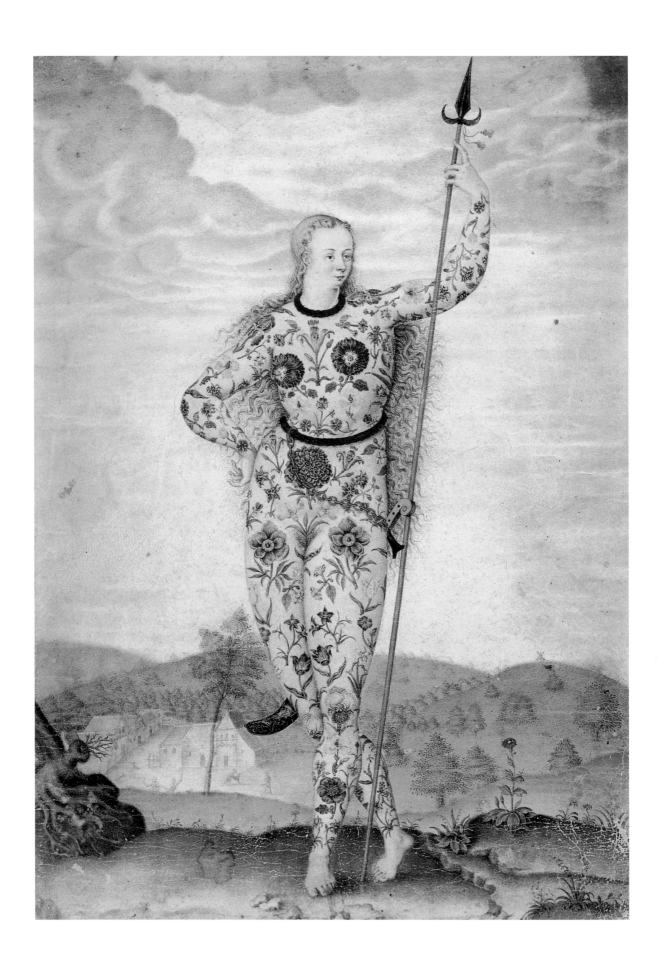

Introduction
A Passion for Flowers

Anna Pavord

Flowers are born to seduce, although we were never the prime targets. The shape of a particular bloom, the subtle variations of its colour, its texture and its scent evolved to lure insects and humming birds, the pollinators that enable flowers to perpetuate themselves. However, although the seduction may not have been aimed at us, we have nevertheless been enslaved. Before flowers even had names, men brought them into their gardens and cultivated them, initially for their practical uses (most medicines were based on plant extracts) and then for their beauty. Transplanted into new habitats, cosseted, protected from grazing animals, the plants prospered and increased. We thought we were using them: they, of course, were using us.

Roses, lilies, irises, peonies, columbines and carnations were the first ornamental flowers to decorate European gardens. You see them in Hans Memling's *Vase of Flowers*, painted c. 1490 (Fundacion Colleccion Thyssen-Bornemisza, Madrid) and in the portrait of Sir Thomas More and his family, painted in 1526 by Hans Holbein the Younger (The National Trust, Nostell Priory). But by the time the Flemish painter Jacques Le Moyne de Morgues

produced his strange miniature, *A Young Daughter of the Picts*, in watercolour on vellum, c. 1580 (Yale Center for British Art, Paul Mellon Foundation), a wild, flamboyant tribe of Eastern flowers had crossed from the harems of Constantinople into mainland Europe. In de Morgues' picture, the Pictish girl stands in a chilly landscape wearing nothing but her own long hair and a sword. Arranged symmetrically over her body like tattoos are heartsease and columbine, cornflowers and poppies. So far, so familiar; since monks first decorated the margins of medieval manuscripts, these flowers had been the favourite subjects for artists. But now they are joined (and completely outclassed) by exotic foreigners. Vast purple *Iris susiana* decorate the girl's knees. Tulips, unknown in Europe before 1559, flower on her thighs. The white Madonna Lily, so often used in religious paintings to symbolize the purity of the Virgin Mary, is ousted by hot orange Turks cap Lilies, which blaze proudly on her breast and abdomen. Although in 1529 the Turks themselves had been turned back from the gates of Vienna, their flowers went on to conquer the whole of Europe.

These exotic lilies, together with the hyacinth, iris, fritillaries and ranunculus that flooded into Europe from the middle of the sixteenth century, fed a fever for flowers, which was a defining characteristic of the next hundred years. Rich men built

up vast collections of auriculas and carnations, tulips and anemones. Francesco Caetani, Duke of Sermoneta, had 29,000 anemones in his garden at Cisterna, south of Rome. Sir Thomas Hanmer of Bettisfield in Flintshire specialized in auriculas, which he called 'bears ears'. In England, of course, the seventeenth century was a period of internal conflict: under the Stuarts there were two civil wars, a regicide, a republic, a restoration and a revolution. Despite this time of strife, Hanmer, a staunch Royalist, still found time for his beloved flowers. With one hand he levied troops to fight for the King on his patch in north Wales; with the other he sent tulips to John Lambert (1619–83), one of Cromwell's generals. Lambert, like Hanmer a besotted tulip fancier, lived at Wimbledon Manor, where he had a renowned garden. Hanmer sent him 'a very great mother-root of Agate Hanmer', one of his best tulips. Flowers transcended even the Civil War, perhaps the most cataclysmic event in British history.

For those who could not afford the flowers themselves, an alternative was to commission an artist such as Ambrosius Bosschaert or Balthasar van der Ast to do a painting of the flowers. Roelandt Savery was one of the first artists to paint bouquets, the image providing a substitute for the fragile, ephemeral flowers themselves. His *Flowers in a Roemer*, 1603, shows a glass vase set in a niche and filled with roses, iris, fritillaries, wild orchid, forget-me-not and tulips, the latter being the sexiest flower of the age. In the 1630s, the cost of commissioning a top artist to produce a flower painting was a fraction of what it would cost to put together the same arrangement of real flowers from the garden. The grand master of Dutch flower painting, Jan van Huysum, could rarely command more than 5,000 guilders for a painting. A single bulb of the tulip 'Admiral Liefkens', however, changed hands for 4,400 guilders at an auction in Alkmaar on 5 February 1637, while 'Admiral van Enkhuijsen' was even more expensive, at 5,400 guilders. The last of the big spenders bid at this auction: 99 lots realised 90,000 guilders, perhaps as much as £6 million in today's money.

In the decorative arts, from the seventeenth century onwards, flowers bloomed with abandon. They were painted on money chests (Frans Hals Museum, Haarlem) and inlaid in mother-of-pearl on the Kunstkabinets and Wunderkammer that were so popular as display cases at that time. Flowers flamed in stained glass, curled round the bowls of porringers and wassail cups. They were stitched into bed hangings, tapestries and curtains, woven into the borders of Flemish tapestries, or arranged in bouquets which often seem to have been copied from the flower paintings produced at that time by Savery, Jacques de Gheyn, Ambrosius Bosschaert and their contemporaries.

From the late sixteenth century onwards, flowers also provided a map of the movements of the many people persecuted for their religious beliefs. Like messages written in invisible ink, flowers emerged slowly in the new grounds that Flemish and French refugees were forced to seek in the wake of the Catholic crusades of Philip II. In the second half of the sixteenth century, these Protestant Huguenots brought gilliflowers, Provence roses and carnations into England. Many of the immigrants were weavers and some settled in Norwich, at that stage the second most important city in the country. These immigrants/florists were not flower sellers, but hobby growers (usually men) dedicated to the breeding, culture and exhibition of six specific flowers: anemone, auricula, carnation (or pink), hyacinth, ranunculus and tulip. The first florist's feast was held at Norwich on 3 May 1631 when, after the feast itself, guests were entertained by the staging of a play *Rhodon and Iris* (Bodleian Library, Oxford). The feast received a poor reception

from the Norwich Puritans who disapproved of suchcarousings, dedicated as they were to the pagan goddess Flora.

A second wave of French Huguenots arrived in England in the 1680s, escaping persecution by Louis XIV, furthering a massive explosion of flower growing in England between 1680 and 1710. In consequence, nurserymen flourished. In September 1684, from his nursery at St Martin's in the Fields, London, Roger Looker supplied the Marquis of Bath at Longleat with 4,000 crocus roots for £2. In 1689 George Ricketts, a Hoxton nurseryman, sent '100 lillys (white) of Constantinople, 50 Campernello, 200 Good Tulipps mixt, 100 Ranunculus' to Leavens in Westmoreland. The lilies cost 12 shillings, the ranunculus £1. Seeing commercial advantages in the feast introduced by Norwich florists, Thomas Wrench (c. 1630–1728), auricula grower and nurseryman of Fulham, established the first of a series of London feasts.

The later growth and popularity of florists' societies – then growing auriculas and tulips, pinks and ranunculus – was helped greatly by the growth and popularity of newspapers. Norwich was one of the first provincial towns in England to have its own paper, the *Norwich Gazette*. On 28 June and 5 July 1707, the *Gazette* carried details of 'The Florists Feast, or Entertainment for Lovers of Flowers and Gardens', which was to be held at 'Mr Thomas Riggs in St Swithin's Lane on Tuesday the 8th day of July next.' Tickets cost half a crown, so Mr Riggs was evidently expecting some well-heeled florists.

By the middle of the eighteenth century, florists' societies had been established all over England. Early newspaper advertisements for florists' 'feasts' like Mr Riggs's at Norwich were replaced by coverage of shows, such as the tulip show held at the White Horse, Bury St Edmunds, where 'lovers of these amiable bulbs' could win a silver punch ladle for the best bloom (*Ipswich Journal*,

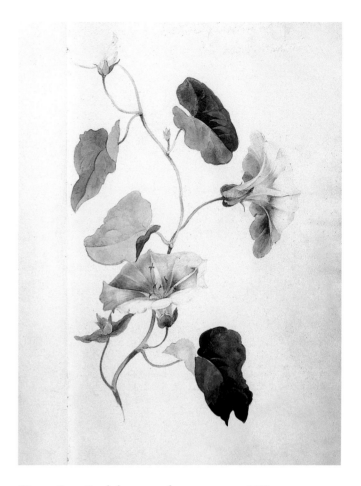

WILLIAM PEGG, *Convolvulus*, watercolour on paper, c. 1813.

21 April 1750). However, since it was usually pubs, such as Thomas Oxley's establishment, the Three Stags' Heads at Sheffield, or the Crown Inn, Nottingham, which offered convenient meeting rooms for the flower shows, carousing continued just the same. The arrangement suited both parties: the florists got a venue at a minimal sum and the landlord sold vast quantities of ale.

The growth of florists' societies in the nineteenth century was the result of a new self-confidence emerging in a different type of British grower. During the seventeenth and much of the eighteenth century, florists' flowers had been rich men's playthings, acquired to show off the owner's good taste

(and healthy bank balance). As new fashions took over in the grand gardens, these old flowers, the auriculas, the ranunculus and the beautiful striped carnations became *demode*. From the late eighteenth century onwards, florists' flowers were, in the main, bred, developed and shown by artisans, such as the gunsmith John Findlay, who swept the board at the Paisley Florists' Society in 1796, or the shoemaking Gill family of Wakefield in Yorkshire. Sheffield was another safe haven, where Benjamin Simonite, a cutler like many of his fellow Sheffield florists, found time to breed pigeons, rabbits and greyhounds as well as flowers. George Crabbe noted the trend in *The Parish Register*, 1807 where in a florists' garden:

> 'The reed-fence rises round some favourite spot
> Where rich carnations, pinks with purple eyes,
> Proud hyacinths, the least some florists prize
> Tulips tall-stemm'd, and pounced auriculas rise.'

James Sowerby showed the best of these flowers in *The Florist's Delight*, which he issued in three sets from 1790 onwards. Various florists, said Sowerby, had 'expressed a wish to see some of their best Fancy Flowers delineated'. Each set contained six engravings of florists' flowers, but business was slow and the project foundered after Plate XVIII.

Sowerby's lack of success did not deter Robert Thornton from beggaring himself with his own *Temple of Flora*, published between 1798 and 1807. A group of six tulips, painted by Philip Reinagle, was Thornton's choice for the first of the prints made for the work, but despite netting some distinguished patrons, Thornton's work was a financial disaster. He had to write an 'Apology' to his potential subscribers and attributed his problems to the fact that 'The once *moderately rich* very justly now complain that they are exhausted through *taxes* laid on them to pay armed men to diffuse *rapine, fire* and *murder*, over *civilised* EUROPE'. War had broken out against France in 1793 and peace was not finally established until after the Battle of Waterloo in 1815.

In the potteries, workers translated their love of the flower onto the china they were painting. From the early nineteenth century onwards, flowers decorated much of the porcelain painted in enamel colours and gilt made in the china factories, for instance, by the Derby factory. Derby's star flower painter was William Pegg, born in 1775. By the age of ten, Pegg was already working in the potteries and after three years, became apprentice to a china worker, working fifteen hours a day in the factory. In 1796 he was offered a five-year contract at the Derby China works, which was booming after taking over the illustrious Chelsea pottery. But Pegg, who had heard John Wesley preach in Staffordshire in 1786, began to worry about the morality of decorating expensive porcelain with sinfully beautiful flowers for the tables of rich clients. In 1800 he became a Quaker and abandoned his paintbox to start a new and spectacularly unsuccessful life as a stocking maker. Stockings may have satisfied the inner man but did little to sustain the outer one. Close to starvation, Pegg was forced to return in 1813 to his former work at the Derby China works, filling pages of a sketchbook (c. 1813, Royal Crown Derby Museum, see p. 58) with elegant florists' tulips and other flowers, which later found their way onto Derby's porcelain. After four years, plagued once more by religious scruples, he left the Derby factory for good and died, destitute, in 1851.

Despite pockets of dedicated growers, especially in Derbyshire, Lancashire and Nottinghamshire, interest in the florists' flower began to decline towards the end of the nineteenth century. It was not easy to transport to the show bench in a perfect state and the tribalism that had fuelled so many enjoyable spats among the exhibitors of florists' flowers could now be displayed in more passive ways, such as identifying with a football team.

Association Football's first cup final was played in 1871 and from the 1870s onwards, most towns of note had their own clubs. The rapidly changing faces of towns and cities also contributed to the decline. The 1851 census had revealed that, for the first time in British history, more people lived in urban areas than in the country. An economic boom fuelled the growth of industrial centres such as Manchester, Sheffield, Nottingham and Derby, but one cost of the industrial boom was the loss of many of the small plots where generations of flower lovers had grown their flowers.

Many of these plots were covered by villas, occupied by a new group of people, the burgeoning middle class. Their gardens were spacious but not big enough to accommodate flowers that could be cut in quantity for the house. Cutting gardens, full of delphiniums and peonies, roses and chrysanthemums, were a standard feature of big country gardens. Those lucky few who owned big estates had regular supplies of their own flowers sent up to them from the country if they happened to be in London for the summer season or in Scotland for the grouse. They rarely needed to buy flowers, though for parties they sometimes hired palms, ferns and flowering plants in pots. These were grown by professionals, often called market-florists, to distinguish them from the hobby florists who had exhibited their auriculas and pinks in hotly contested competitive shows.

Slowly, though, the new middle class created a market for cut flowers, a demand mirrored in the pages of the *Gardeners Magazine*. This superb publication, founded in 1826 by John Claudius Loudon, was aimed at the vast army of professional gardeners and nurserymen then working in Britain. Each week it carried reports of prices achieved for various commodities at Covent Garden market: Newton Pippin apples, Beurre Rance pears and various potted plants, such as orchids, fuchsias,

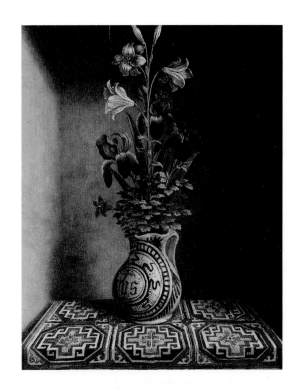

HANS MEMLING, *Still Life: Maiolica Vase with Flowers*, c. 1522

pelargoniums and mignonette. From 1877 onwards, prices for cut flowers were published for the first time and in January that year carnations, chrysanthemums, euphorbias, gardenias (the most expensive), heliotrope, Roman hyacinths, lilies of the valley, narcissus, primulas, stephanotis and violets appeared in the list. Thirty years on arums, freesias, *Lilium longiflorum* and mimosa appeared in the January list of prices. Parma violets cost 8 shillings a bunch at a time when 'a thoroughly experienced head gardener, no small children, wife to do washing' earned no more than 28 shillings a week. Today cut flowers, dumped in a bucket in a petrol station forecourt, are as cheap as a cup of coffee. But, with their genes modified to fit a grower's blueprint, have our flowers grown more beautiful than their cousins, painted by Nicolas Robert and Jan van Huysum in the seventeenth and eighteenth centuries? Judge for yourself.

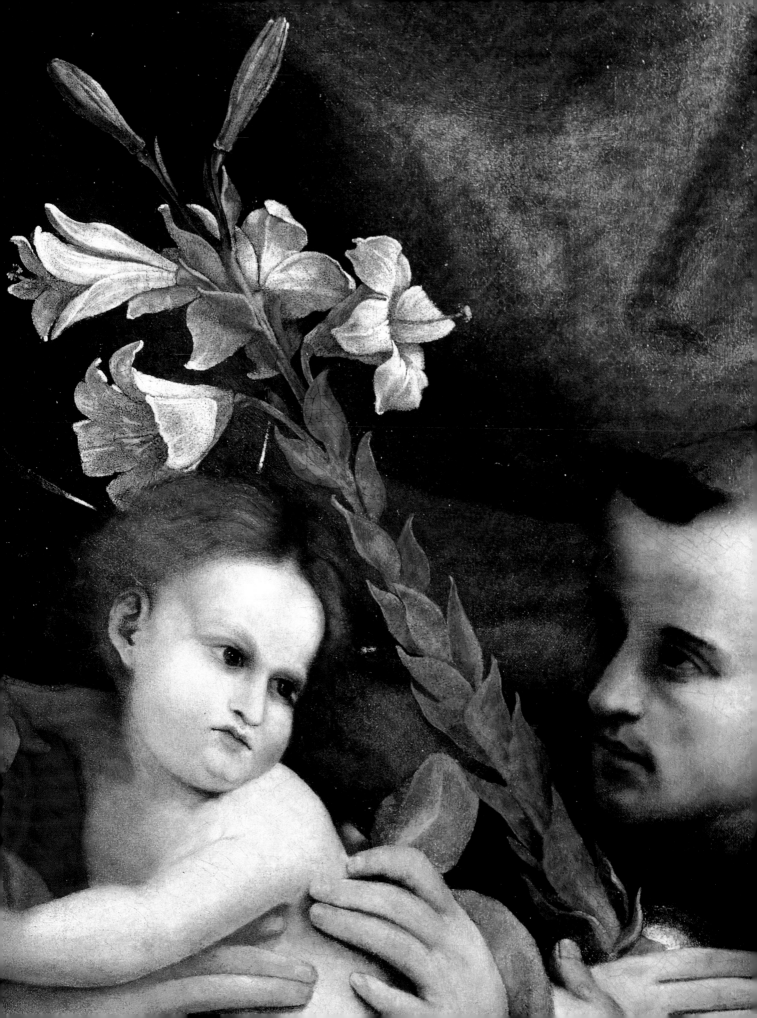

1

The Flowers of Faith

Early representations of the cut flower in art here include an early altarpiece and an illuminated manuscript to depict the first flowering of western art and the symbolic purpose of flowers in Christian art. The selection also illustrates later religious symbolism in both Western and Eastern traditions.

Within the Christian tradition flowers have been used to convey many of the themes associated with early customs, myths and legends. This is particularly pertinent with regards to flowers associated with the Virgin Mary. The Virgin Mary is indentified with the sweet smell of ambrosia and addressed as the 'lily of the field', the 'rose of Sharon' and the 'bundle of myrrh'. In paintings of the Annunciation the angel Gabriel greets her with a lily staff and we are invited to sense the perfume of incorruptibility. If Gabriel does not bear the lily, a pot will decorate her room or, in images of her Assumption, her empty tomb will sprout lilies or roses. In *Ecclesiasticus* (24,15) the identification with Mary and aromatic smell is made explicit: 'I gave a sweet smell like cinnamon and aspalathus, and I yielded a pleasant odour like the best myrrh, as galbanum, and onyx, and sweet storax, and as the fume of frankincense in the tabernacle …'.

As early as the tenth century the intimate association of the victory of Mary over death with the aromas of herbs and flowers was celebrated in the ritual of the feast of the Assumption. Medicinal herbs and plants were brought to church and periwinkle, verbena, thyme and other herbs were laid on the altar and subsequently tied into a sheaf and retained to ward off illness, disaster and death. The service was abolished in England at the Reformation, although the ritual survives in some northern Italian towns (M. Warner, *Alone of all her Sex: The Myth and the Cult Of The Virgin Mary*, London 1983, 99,100).

The rich symbolism of flowers in our daily lives was well established by 1500. The red carnation stood for the Christ's Kingship and Crucifixion (Bergstrom 345), but also betrothal (Kear 176); the Columbine represented Christ's Passion and Salvation, the Holy Ghost and the Dove of Peace (Heilmeyer 20). The orange blossom stood for marriage and fruitfulness (Lehner 122), the forget-me-not was associated with loss and remembrance (Fisher 74); the iris, like the lily, was linked to the Virgin Mary, but also to royalty and chivalry, hence becoming the fleur-de-lys of the French monarchy (Tongiorgi 6; Coats 126-7). These meanings held great power in the sixteenth century, and continued to do so through the following century.

Although these examples illustrate the Christian tradition, many flower symbols shared with or owed their mythic origins to Eastern cultures. In China the chrysanthemum symbolized fertility and longevity, joviality and prosperity, ease and rest (Goody 290, 364, 395). The lotus was and remains the symbol of the Buddha, of perfection and purity, transcendence and the manifestation of the eternal within us (Goody 335). The origins of the sunflower as a symbol of the sun lay with the Incas (Lehner 48). Many of these meanings have continued to influence Western traditions, as their influence has spread. AM

Lorenzo Lotto, *The Virgin and Child, with Saints Jerome and Nicholas of Tolentino* (detail), c. 1522

The Nativity

from *The De Croy Book of Hours*

Unknown French artist, c. 1470

Manuscript illumination on vellum, Leaf size 10.2 x 7 cm

Sheffield Galleries and Museum Trust, Collection of the Guild of St George

This finely wrought miniature is by an unknown French master who deserves to be recognized as an artist of considerable stature. This can also be said of the painter of the floral border, almost certainly a different artist who specialized in the combination of naturalistic and stylized leaf and flower motifs in this and other miniatures within this Book of Hours. The Nativity scene is one of the original miniatures in a devotional Book of Hours of the Virgin and is supported by a border that features naturalistic blooms. The Flemish School of miniature painters are the best known for their naturalistic treatment of such borders, where their flowers appear to rest upon the page: here a French master reveals a more Gothic sensibility, combining naturalism with decorative stylization, in addition to selective symbolism.

The aquilegia or columbine (*Aquilegia vulgaris*), shown lower left, is not solely decorative in intention, but refers directly to Christ's Passion. The Latin name aquilegia is thought to have been derived from aquila, or eagle, on account of the spurs of the flower resembling an eagle's talons. Equally, the shape of the bloom's nectar gland is reminiscent of a dove, the origin of the name columbine (from *columba*, for dove). It is this last association which led to the flower being identified with the dove of the Holy Spirit and Redemption. In this sense the bloom directly refers to the Saviour, rather than the Virgin. A flower that represents Mary, top right, is the daisy

(*Bellis perennis*), symbol of humility, love and modesty, which in France was named the 'Marguerite', after the Latin *margarita*, for pearl. Similarly, the highly realistic depiction of the specimen below (*veronica species*) is a specific link to Mary, its more common name being 'Lady's Faith'. The Periwinkle (*vinca minor*) on the upper left-hand side provides a third reference to the Virgin, as it was known as 'the Virgin's Flower'. The tricolour pansies, lower right, are emblematic of the Holy Trinity and faithfulness (Heilmeyer, 20,56,80).

The usual status of *The Nativity* (Luke 2, 6–7) within a Book of Hours of the Virgin is to introduce the third stage of a day of devotion, after *Matins* and *Lauds*, known as *Prime* time, which began at 6 am. The De Croy Hours, named after Diane de Croy, the sixteenth-century owner of the book, is a typical example of such a devotional volume. Rebound in the eighteenth century, it now includes an *Annunciation* attributed to Jean Fouquet and the correct order of the canonical hours of a monastic day and some of the original illuminations are lost. Diane de Croy also used the manuscript as an *album amicorum*, in which friends and family copied out verses and good wishes: among those acquaintances to do so was Mary, Queen of Scots (a cousin of Philip de Croy of Chimay, Diane's husband) while in exile in France (J. Griffiths, *The De Croy Book of Hours*, The Ruskin Gallery 1993).

AM

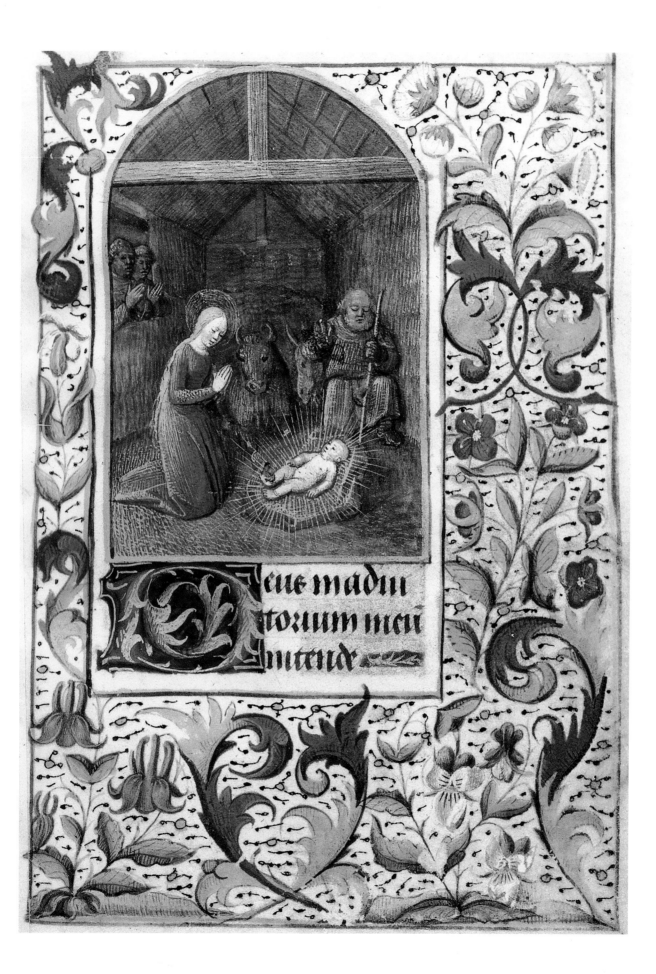

The Virgin and Child
with Saints Jerome and Nicholas of Tolentino, c. 1522

Lorenzo Lotto (c. 1480–1556)

Oil on canvas, 89.5 x 74.3 cm

National Gallery, London

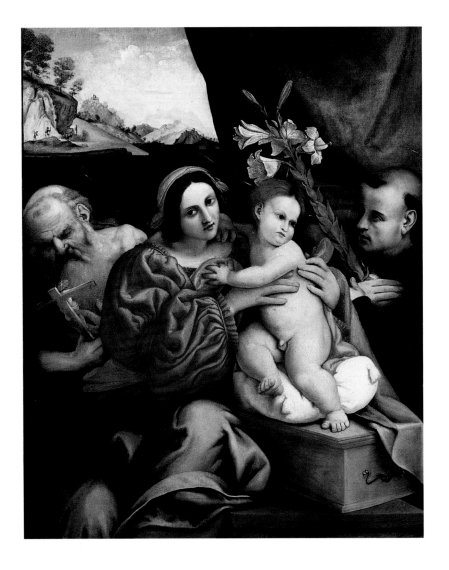

Lorenzo Lotto here achieves an extraordinarily intense image of the Virgin and Child in the company of two saints, both of whom carry the symbols of their holiness. While St Jerome contemplates the crucifix, St Nicholas of Tolentino, wearing the black habit of the Augustinian order, holds large Madonna lilies close to his breast. The lilies both make manifest his devotion and give protective shade for the young child, glowing with radiance in a position that takes the place of a halo.

The lily in this instance (*Lilium candidum*) has a meaning that is not that associated with the annunciate Archangel Gabriel. Here the virginity of the saint is invoked, but in a context that gathers additional meaning. The Christ Child stands unusually upon a coffin in direct reference to His ultimate Passion as also suggested by the crucifix of St Jerome. A lily in Christian iconography, when seen in the context of the Last Judgement, symbolizes innocence and Lotto here invites us to recognize the innocence of the Christ Child in poignant prefiguration of His coming sacrifice to save us. Christ here bestrides death, stamping on the symbol of our transience without petulance.

Lotto's use of the lily candidum to denote virginity has an ancient lineage. In ancient Greece it was the flower of Hera, the goddess of the moon, earth, air, woman's life, marriage and childbirth. In ancient Rome it was the emblem of the goddess of light, sky, marriage and motherhood (Lehner 22). The ancient Hebrews also took the lily as a symbol of chastity. The lily has been cultivated for well over three thousand years. Dioscorides in the first century AD attributed to it many medicinal virtues: the bulb is highly mucilaginous and boiled in water or roasted and beaten into an ointment was used as a poultice or dressing. In monastic gardens it was esteemed both for its beauty and medicinal use. (Rix and Stearn, 36).
AM

Enamelled spoon,
15th century

Probably Flemish
Silver gilt with red and green enamelled roses,
Length 18.1cm
The British Museum, London

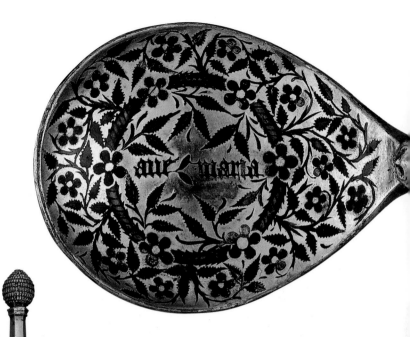

The bowl of this spoon is remarkable due to its elaborate enamelled decoration. It is engraved at the centre with the words 'Ave Maria' (Hail Mary) surrounded by what appear to be stylized roses. The serrated edge of the leaf and a number of small thorns certainly support this interpretation, as does the traditional symbolic association of Mary with the rose. This imagery continues up the first section of the shaft with the words 'Ave Maria Gracia'.

The five petals of the wild rose sometimes represented the five letters of Mary's Latin name *Maria* as well as traditionally symbolizing the five 'mysteries' of each round of the rosary prayer cycle. The very name of the rosary is derived from the notion of a rose garden, often represented in medieval literature and imagery as an enclosed or secluded garden symbolizing purity and allegorically representing the Virgin Mary. By the seventeenth century the symbolism of the rosary had developed into the notion of a garland or headpiece of red roses representing the 'Sorrowful Mysteries', yellow roses the 'Joyful Mysteries' and white the 'Glorious Mysteries'.

St. Ambrose, writing in *De Virginibus* in the fourth century AD, simply describes the enclosed garden of holy virginity where 'the red roses of chastity' grow. In contrast to the roses seen on the spoon, he also identified Mary as the 'rose without thorns'. This reflected the notion that the rose which grew in the Garden of Eden was without thorns. These were held to have appeared only after the Fall as symbols of original sin. Mary was believed to have been born without the stain of original sin and this notion of Her Immaculate Conception was often represented by the lily of the valley.

The function or purpose of this rare and unusual spoon is not immediately obvious. It is unmarked, but is probably Flemish, and is constructed so that it unscrews in two places – the middle of the shaft and just above the beast-head, which joins the shaft to the bowl. As a result, it can fit into a small travelling case made of decorated boiled leather. It is unlikely that it played a specific religious ceremonial role, although spoons did have a limited function in pre-reformation church ritual (a spoon was sometimes used to transfer a small drop of water into the communion wine prior to consecration). The sectional structure of the spoon might suggest that it was intended for use on pilgrimage but this is far from certain.

It is interesting to note that an inventory of Henry VIII's Jewel House taken in 1521 lists twenty-four gold spoons with red roses but in this case they were presumably secular spoons with Tudor heraldic motifs.

CG

21

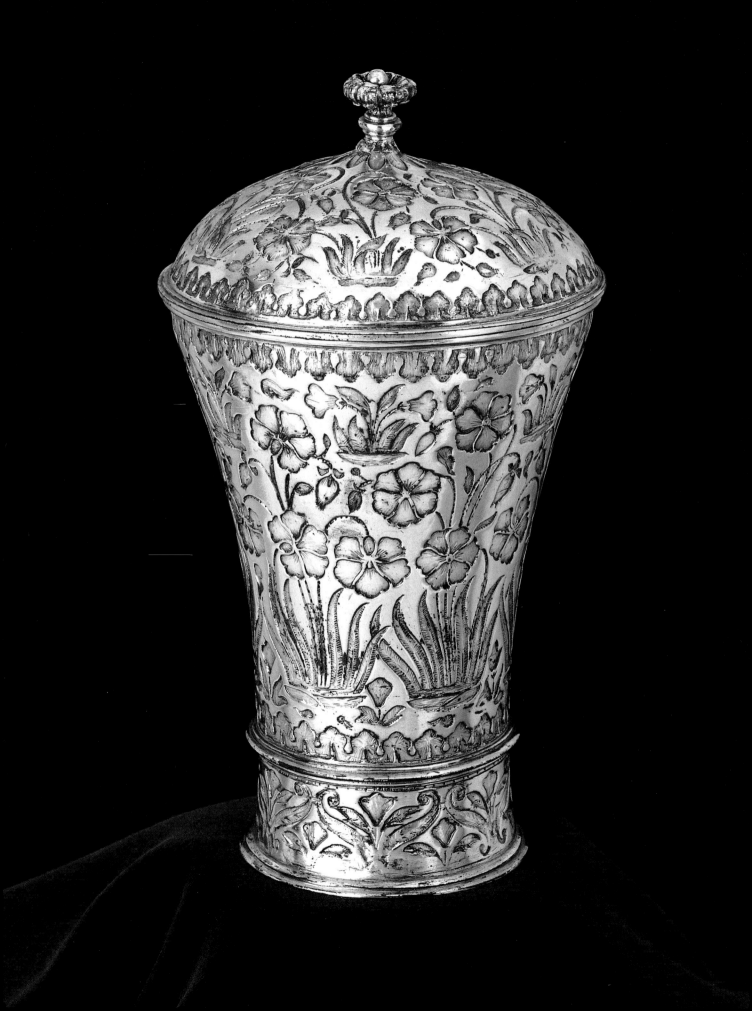

Beaker and cover

Mughal, 2nd half of the 17th century

Silver, raised with cast finial, chased and engraved decoration, Height 14.2 cm

Victoria and Albert Museum, London

Although made in the court workshops of the Mughal emperors, a European beaker has been used as a model for the form of this silver beaker and cover, with its gilt interior and chased and engraved decoration of flowers. The cover is of Indian form but its naturalistic flowering plants, formally arranged in horizontal rows, are derived from European herbals.

The sophisticated culture that developed around the Mughal court was led by the emperors, whose interests in architecture, painting, music and poetry made them foremost patrons and practitioners of the arts. Their court life was established by a conquest that built an empire over all of northern India and sustained it by an effective government authority and a supporting bureaucracy. Luxury goods produced by the imperial workshops included carpets and other rich textile furnishings, illustrated manuscripts, metalwork, wood, glass, precious jewels, perfumes, clothes, tents and weapons (Victoria and Albert Museum, *The Indian Heritage: Court Life and Arts under Mughal Rule*, London 1982, 15, 25, 112).

The refined sensibilities of the dynasty derived from a passion for the natural world that was inherited from the first Mughal emperor, Akbar. This passion also included a fascination with the exotic goods of European traders who, anxious to secure trading privileges, followed the Mughal court practices of giving and receiving rich gifts. This cultural interchange had a significant effect on the form of the floral-based ornament celebrated by the court. The style of the floral ornament established in India by the invading dynasty was drawn from the scrolling and stylised patterns of Persia. Gardens were a foretaste of Paradise for both cultures and the products of the imperial workshop ensured the creation of heaven on earth.

During the reign of the Emperor Jahangir, the style became characterised by naturalistic flowers. In March 1620 Jahangir made a trip to Kashmir, where he was overwhelmed by the beauty of its flower meadows, its tulips, jasmines, red roses, lilies, violets and narcissus (Daniel Walker, *Flowers Underfoot: Carpets of the Mughal Era*, New York 1997, 81–86). This visit was recounted in great detail in his memoirs, and a poem recited by Jahangir evokes his passion:

> There were flower-carpets and fresh rosebuds,
> The wind fanned the lamps of the roses,
> The violet braided her locks,
> The buds tied a knot in the heart.
> (Walker, 1)

Jahangir commissioned his most accomplished natural history painter, Mansur, to make more than 100 paintings of flowers, of which three are known to have survived. Although undocumented, it is certain that there were European herbalists at the Mughal court. Indian naturalism was combined with European herbalist formality and the flowering plant as a design motif created a style that came to dominate all aspects of Mughal art, including architecture. The new floral style was introduced by Jahangir, and popularised by his successor, Shah Jahan, the builder of the Taj Mahal (Walker, 3–6). DC

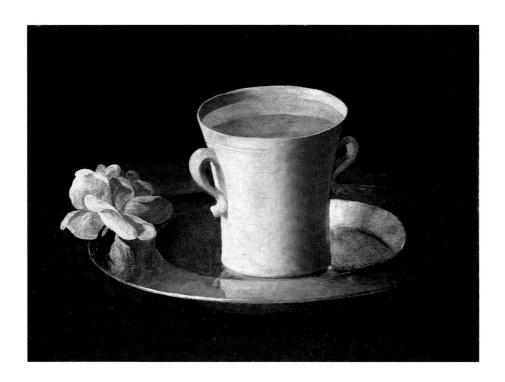

Cup of Water and a Rose on a silver plate, c. 1630

Francisco de Zurbaran (1598–1664)

Oil on canvas, 21.2 x 30.1 cm

National Gallery, London

Zurbaran painted relatively few independent still-lifes although his work includes many still-life elements. The apparent simplicity of this composition is deceptive as the image is invested with devotional meaning. The silver plate has been identified as typical of imports from Peru into Spain at this time. The cup is painted at an angle to emphasize the water it contains, while the rose is placed and painted with extreme delicacy. These elements almost certainly combine to allude to the Virgin Mary, to both her purity and her title of 'Mystic Rose'.

The canvas has been cut on three sides, which could suggest that this composition was destined for a larger devotional painting but the work of art retains its power to move not only the devout. This particular combination of motifs was a favourite with Zurbaran, who is known to have painted two other religious subjects which include a cup of water and a rose on a silver plate, notably his *Still Life with Oranges*, dated 1633, now in the Norton Simon Museum, Pasadena, California. Zurbaran

painted subjects for meditation that display extraordinary pictorial sensitivity and intimacy, acquiring an almost transcendental quality, throughout his lifetime.

The rose as an emblem of Marian devotion was especially recognized by the Dominican Order. St Dominic had instituted the devotion of the rosary with direct reference to Mary and with roses as symbolic of prayer (Friend, 98). In Christian tradition the rose symbolized Mary's heavenly, unspoken love, whereby words spoken in confession under the rose (literally in the middle of the canopy of the confessional) were – and remain today – 'sub rosa', not to be repeated (Woldbye, 47). It was Zurbaran's ability to capture this inner life of objects and nature that characterizes his sensibility as an artist able to transform simple geometric forms into profoundly moving works of art. AM

Figure of Avalokitesvara,
12th century

Eastern Indian

Bronze with silver and copper inlay, Height 13 cm

The British Museum, London

The figure represents the Buddhist divinity *Avalokitesvara* decribed as the 'Lord gifted with complete Enlightenment' in the form of *Padmapani*, the lotus holder. He sits on a stylised lotus with his right foot also resting on a flower. At the same time he holds in his left hand a lotus, originally inlaid with precious or semi-precious stones, while another stands beside him.

The lotus or Indian water-lily of the genus *Nelumbo* is a symbol common to all Indian religions and represents purity; it is seen to grow out of mud and dirty water but remains clean and unsullied. Lakes covered with lotus flowers were one of the signs with which the universe showed its joy at the miraculous conception of Prince Siddhartha who would later become Buddha. Similarly on taking his first steps, a lotus flower appeared as soon as his foot touched the ground. The lotus is also used symbolically in Hinduism where it has long been identified with the Vedic sun-god *Surya*, usually represented holding a lotus in each hand.

The mystical or holy qualities of the lotus can be found as early as ancient Egypt where it is a bud of the Egyptian water-lily of the genus *Nymphaea*, from which the sun-god and creator *Ra* (*Re* or *Phra*) was believed to have emerged.

This sense of flowering beauty emerging magically from an apparently inert seed or from inauspicious soil underlines the symbolic power of flowers in general and explains why they have been repeatedly adopted by different religions as symbols of incarnation, holiness or new life. This is reinforced in cultures where the dead are returned to the earth. The obvious visual connection between flowers emerging from the ground and the site of the grave allows them to represent either re-birth or resurrection.

In Eastern cultures, where cremation is the norm, the lotus is taken to symbolise the endless cycle of life and death due to the manner in which its petals open and shut each day.

A Buddhist *mandela* in the form of a lotus flower is a small, usually bronze, shrine made to be placed on an altar of a temple or monastery. The hinged petals of a *mandala* open to reveal the central figure of a Buddha surrounded by divinities known as *bodhisattvas* on the inside of each of the lotus petals. As a result of the portable nature of these shrines, they were widely dispersed with versions known in Tibet, Burma, Indonesia and China. (W. Zwalf (ed.), *Buddhism: art and faith*, London 1985 (The British Museum Press) 115, no.153). CG

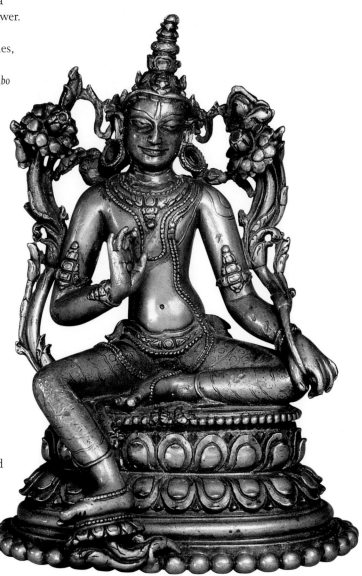

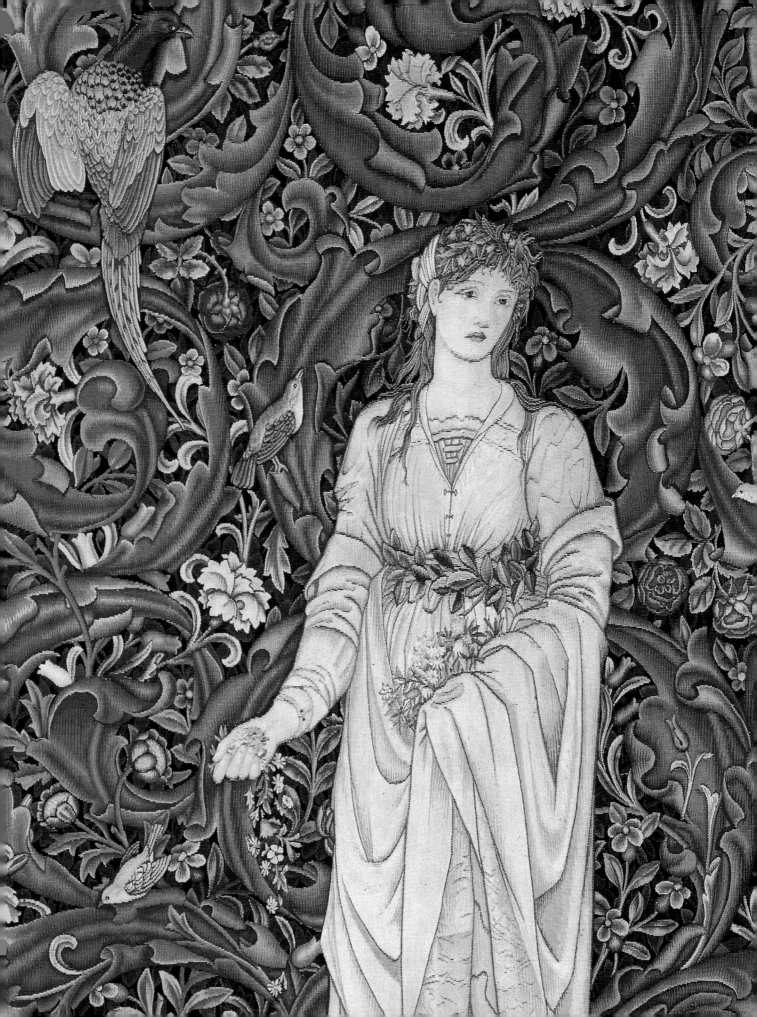

2

'All human life is like a flower …'

D Y N A S T Y ❀ A D O R N M E N T ❀ I D E N T I T Y

The aphorism 'all human life is like a flower …' makes manifest the long-held idea of identifying human existence with the symbolism of flowers. The power of flowers to symbolize belief systems has been used throughout history to establish dynastic power and authority, notably by monarchies. In Europe the French monarchy chose the fleur-de-lys; in England the white and red rose at first personified separate houses and then the supremacy of the Tudor rose was established through the dynastic and political marriage of King Henry VII to Elizabeth of York. The most recent example of this political motive in Britain has been the adoption of the red rose by the Labour party as its emblem in the late twentieth century.

In Tudor England the meaning of flowers was richly disseminated through the visual arts. The urge to bedeck oneself with flowers found expression originally in the myths of Ovid's *Metamorphoses*, where stories of changing identity were established, in a world where garlands of flowers were the accoutrements of the Gods. The plays of William Shakespeare provide an abundance of evidence for the literary tradition of the language of flowers in everyday life in England at this period, often drawing upon Ovid and medieval European tales that play with identity and transmogrification. The Tudor and then Jacobean courts created fashions of dress whereby flowers and their associated meanings could be emblazoned upon the courtiers attire and accoutrements, establishing their status and wealth. These meanings and the images themselves were established and circulated through herbals and printed books.

The meanings of flowers could change: the carnation in the sixteenth century came to mean fidelity and true love, friendship and betrothal, losing some of its association with Christ. The columbine became synonymous with adultery and cuckoldry, emblematic of the deserted lover (Goody 180; Friend 130). In Eastern cultures Japan took up the chrysanthemum as a symbol of the Sun and of life, also adopting it as the national flower. The lotus became the national flower of Egypt and India, while in China it was adopted as the symbol of summer (Lehner 120). The tulip made its first appearance as a symbolic flower in Persia, the emblem of the perfect lover (Lehner 81).

The most powerful use of flower symbolism in the visual arts can be seen when artists choose to identify either themselves or others with the emotions associated with these traditional meanings. One of the most enigmatic examples of this in Western art lies in Anthony Van Dyck's *Self-portrait with a Sunflower*. In the nineteenth century Vincent Van Gogh was to identify qualities in the sunflower with which to honour his friend Paul Gauguin. The idea that meanings in flowers become ever more powerful in European art is made manifest when the symbolism of the sunflower or the lily, to take just two examples, is pursued through the centuries.

AM

Flora tapestry, 1884–85, Morris & Co. (detail)

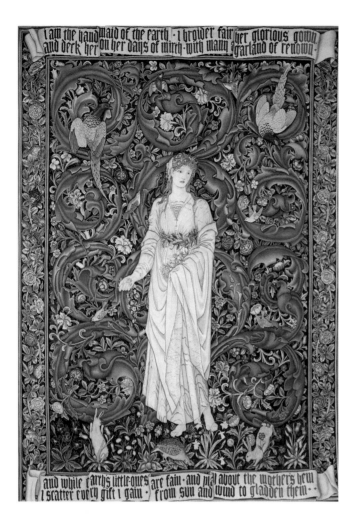

Flora

Morris & Co., 1884–85

Tapestry, wool and silk on cotton warp, 300 x 210 cm

The Whitworth Art Gallery, The University of Manchester

The tapestry of *Flora*, the goddess of flowers, was woven in wool and silk on a cotton warp in 1884–85. It was devised as a pair with *Pomona*, the goddess of fruit. The artist Edward Burne-Jones designed the figures; William Morris designed the backgrounds and borders of foliage, and the flowers and animals. Morris also wrote the verse quatrains (published in *Poems by the Way*, 1891) that form the top and bottom borders of the tapestry. (Oliver Fairclough and Emmeline Leary, *Textiles by William Morris and Morris & Co., 1861-1940*, London 1981, pp. 56, 106).

The richness of detail and colour reflects those of late medieval tapestries, particularly the *millefleurs*

tapestries that Morris admired. Morris considered tapestry, as practised by the weavers of the late medieval period, to be one of the highest arts. He was closely involved with the design and manufacture of tapestries made at the Merton Abbey works of Morris & Co. in southwest London from 1883 until 1892, when political interests and other artistic endeavours drew him away from day-to-day involvement at the works. After his death he was described as 'weaving the art of life into a beautiful pattern'. (Barbara Morris, Introduction in Fairclough and Leary, 9).

As told by Ovid, Flora was pursued by Zephyr, the west wind, who married her and made her the mother of Spring. The Floralia was the festival for this Roman goddess of the flowers, and was celebrated on 1 May. Courtesans participated at this event, suggesting the association of flowers and the pleasures of the senses that they evoke. Representations of Flora can depict her naked and garlanded with flowers, beguiling as a courtesan. Botticelli's Flora (*Primavera*, 1477, Uffizi, Florence) celebrates this moment, her beauty revealed as she exhales flowers and is caught by Zephyr. The Venetian artist Titian used her as an allegory of a virtuous woman, whereas Rembrandt took up the association of love and sensual pleasures, depicting his mistress as a contemporary Flora. She can also be seen as a stately goddess, demanding tribute, in her scorn of fallen tulip speculators.

William Morris portrays Flora as a goddess of ethereal earthiness and far removed from the worldly pleasures of her previous incarnations. As she describes herself in the verse quatrains, her gifts as the earth's 'handmaid' are derived from the elements, given to enhance the earth's beauty and for the benefit of its innocent creatures.

Morris's depictions of Flora's riches are based on his own study of nature, as well as the art of the past and Oriental cultures. As a child, he discovered John Gerard's *Herbal* (1597) and used it as a reference book throughout his life (Linda Parry ed., *William Morris*, London 1996, 224–34). Morris recognized the swirling acanthus of the tapestry's background as one of the oldest ornamental motifs derived from nature, in constant use from ancient Greece onwards. He evokes the woods, fields, hedgerows and gardens of an idealized, medieval world that fed his singular Socialist vision. Writing on design, he said: 'The rose, the lily, the tulip, the oak, the vine, and all the herbs and trees that even cockneys know about, they will serve our turn better than queer upside-down looking growths. If we cannot be original with these simple things, we shan't help ourselves with the uncouth ones.' (From *Hints on Pattern Designing*, Chiswick Press, London 1899, 8, in Oliver Fairclough and Emmeline Leary 1981, 9).　　　DC

Edward VI
as Prince of Wales (1537–53), c. 1546

Studio of William Scrots (fl. 1537–53)

Oil on panel, 35 x 30 cm

Private Collection

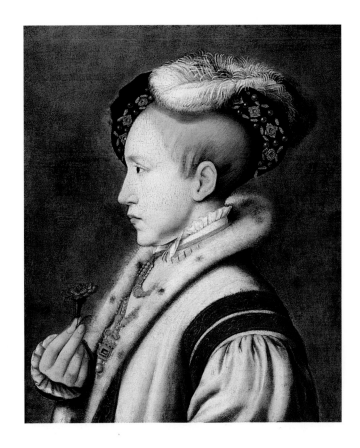

This image of Edward VI is of particular interest as it portrays the young prince holding a flower that defies first expectations. A Tudor prince would normally be associated with the rose: the dynastic marriage of Henry Tudor (1457–1509) and Elizabeth of York, daughter of Edward IV, established legitimacy with the symbolic red and white hybrid Tudor rose. Edward holds not the dynastic rose of the Tudors, but a small dianthus, specifically a pink.

The pink first appeared in Britain in the mid-sixteenth century and the origin of its name is unclear. The pink is a common feature of sixteenth century betrothal portraits and its presence in this subtly delicate image of the young Prince gives a real clue to the purpose behind the commissioning of the portrait. In 1543, after the death of James V, peace was made between England and Scotland, and one of the principal stipulations was that Edward should marry Mary Queen of Scots who was

then not quite one year old. The match remained on the political agenda until 1551: this portrait suggests that it – or one similar – was sent to Edward's intended bride around 1546 when she would have been four and Edward was nine.

Other evidence supports this interpretation of the portrait. The long-awaited male heir to the throne was the subject of intense interest, continuing after his death when the Protestant ascendancy was established in 1558 with the coronation of Elizabeth I: indeed, more portraits of Edward were painted after his death than during his lifetime. Here he wears the jewel with its triple feathers, which was the symbol of the Prince of Wales since the time of the Black Prince. The earliest child portrait of Edward is by Holbein (National Gallery, Washington), presented to Henry VIII as a New Year's gift in 1540. A celebrated small full-length portrait of Edward remains at Windsor. The attribution here to Scrots is based upon similarities with the likeness in the unusual perspective image of Edward dated 1546 which is also associated with this artist (National Portrait Gallery). It is uncertain whether this is the original version or a studio copy of a lost original (Mark Weiss, *Tudor & Stuart Portraits 1530-1660*, The Weiss Gallery 1995, no. 7). AM

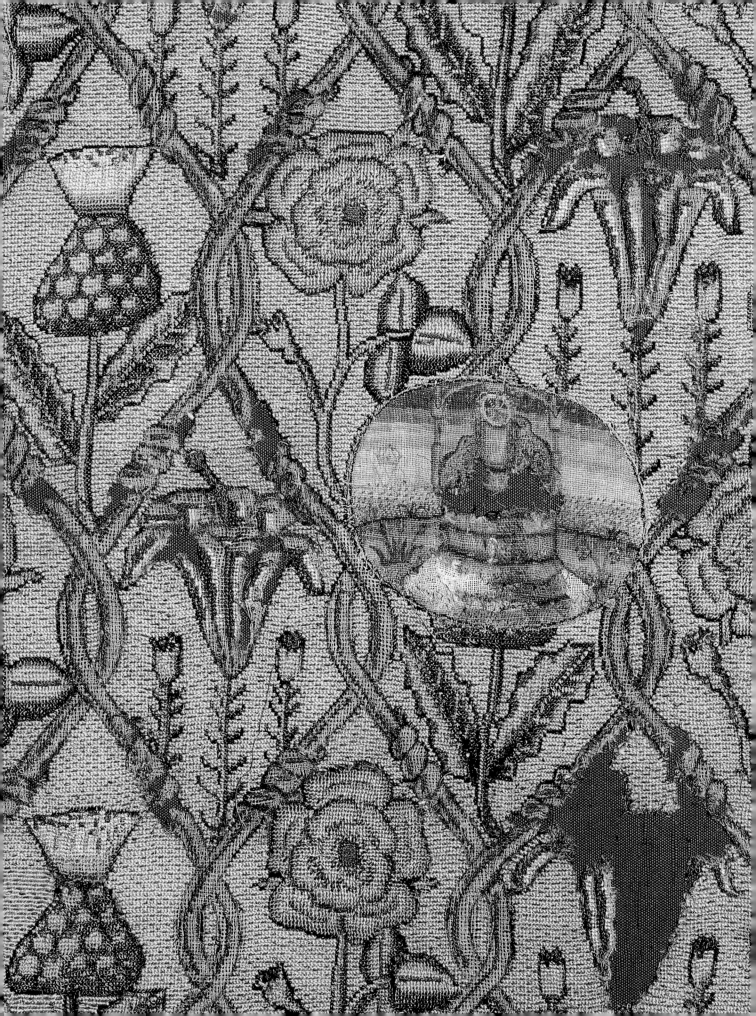

Panel associated with Mary Queen of Scots

Coarse linen canvas covered with silk and silver-gilt thread, 48.5 x 60 cm

Hardwick Hall, The Devonshire Collection

(The National Trust, to which transferred by H.M. Treasury in 1959, after acceptance in lieu of tax)

This embroidered panel, originally a square cushion, is made of a course linen worked in cross-stitch with coloured silks and silver gilt highlights. It shows a diaper pattern of interwoven stems framing roses, lilies and thistles. Five roundels of much finer linen worked in tent stitch have been applied to the centre and each of the four corners.

The panels show scenes from the 1573 edition of Gabriel Faerno's *Fabels* (Santina M. Levey, *An Elizabethan Inheritance, The Hardwick Hall Textiles,* London 1998) but it is the central panel that is particularly significant. It is stitched with the crowned initials MAR for Mary Queen of Scots (1542–87) and the flowers are heraldic emblems referring to her various dynastic claims.

The thistle had been the conventional emblem for Scotland since 1263 and Mary had acceded to the Scottish throne in 1542 before she was a week old. However, her troubled reign came to a dramatic conclusion in 1568 when she was forced into exile by the protestant Scottish Lords who had rebelled against her. Mary fled across the border to England but was regarded with suspicion by her cousin Elizabeth I. On the death of Elizabeth's elder sister Mary Tudor in 1558, the catholic Mary Queen of Scots had laid claim to the English throne (her grandmother Margaret was sister to Henry VIII), hence the inclusion of the rose of England. As a result she would have been regarded as a potential threat by the protestant Elizabeth, who placed her in the custody of the Earl of Shrewsbury until she was eventually executed in 1587.

Shrewsbury's wife, Elizabeth Talbot (known as 'Bess' of Hardwick), was her companion in embroidery during this time. The nineteen years of her imprisonment at various houses in England saw Mary produce a large quantity of embroidery; an inventory of her effects drawn up the year before her death lists fifty-two floral slips in petitpoint. Some, like the hangings now at Oxburgh Hall in Norfolk, included a personal emblem of the marigold turning towards the sun.

The third floral emblem on the cushion, the lily, refers both to Mary's French ancestry – she was the daughter of Mary of Guise and had been brought up in the French court – and to her first marriage. In 1558 she had married the Dauphin, heir to the French throne and on his accession as Francis II in 1559 briefly became Queen of France. However, his sudden death a year later deprived her of this role. The lily here represents the fleur-de-lis of France, which was supposedly based on a lily, although its origin is equally likely to be an iris (as emblems the two flowers are often confused). A scattering of the stylized flowers was first adopted on the French arms by Louis VII in the twelfth century, but this was reduced a century later to the three seen here. It may also be that the lily, traditionally associated with the Virgin Mary, was particularly chosen here by the exiled Queen as a pointed allusion to the Catholicism on which her claim to the English throne rested. CG

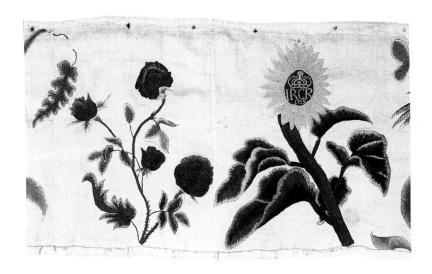

Valance for Wall Hanging, 1719

Scottish, possibly worked by Anne Hamilton

Twill weave white linen embroidered with crewelwork in

coloured wools and silks,

33.5 x 245.5 cm

The Trustees of the National Museums of Scotland

One of a set of four crewelwork valances and two wall hangings embroidered with the 'Tree of Life' pattern, this section shows a number of floral motifs: the Jacobite symbol of a rose and most strikingly a sunflower embroidered with the crowned monogram 'IR CR'. This is for the Old Pretender, James Francis Edward Stuart and his wife Maria-Clementina Sobieska, and the embroidery includes the date of their marriage – '1719'. The sunflower has not been placed centrally but to one side and may have been intentionally inconspicuous within the hangings of the room, perhaps prudent given the political circumstances of the day.

The monogram on the hanging is also found on medals struck to commemorate the marriage of James Stuart and Maria-Clementina in Rome in 1719 (Charles Edward Stuart, the Young Pretender or Bonnie Prince Charlie as he became more popularly known would be born the following year). The monogram may have been incorporated into the sunflower motif when news of the marriage filtered through from the continent. Anthony Van Dyck's *Self-portrait with a Sunflower* makes explicit the sunflower as a symbol for the loyalty of the artist to his patron Charles I. This image would have been familiar to both Royalists during the civil war and Jacobite sympathizers after the 1688 revolution through a number of engraved versions of the portrait in circulation, notably Wenceslas Hollar's etching of 1644. In the case of the bed hanging, this symbolism has been extended to indicate a similar loyalty to the Stuart line, to the 'King across the Water'. The positive attributions of the sunflower underline the celebratory nature of recording the recent marriage with its promise of future heirs.

The hangings are proficiently embroidered but their idiosyncratic style would suggest that they were produced by a gifted amateur rather than a professional needlewoman (Naomi Tarrant, *An introduction to European Decorative Textiles for Home and Church in the National Museums of Scotland*, 2001, 54). The size and extent of the scheme also seem to indicate someone with a comfortably sized household. The maker would have required both the financial resources to purchase the necessary materials and the time to undertake the work unburdened by the need to be an active housekeeper (Tarrant, 56).

A clue to the identity of the owner of the hangings is found on an embroidered hound on one of the large sections. It has a collar with AV worked in Gothic script. At the time 'V' was also used to represent 'U' and this almost certainly stands for Alexander Urquhart of Newhall, Member of Parliament for Cromartyshire from 1715 to 1722 and a known Jacobite sympathizer. His wife Anne Hamilton therefore emerges as the most likely candidate to have produced the embroidery. CG

Elizabeth Vernon
Countess of Southampton, c. 1615

English School

Oil on canvas, 59.5 x 45 cm

Boughton House

By kind permission of the

Duke of Buccleuch and Queensberry, KT

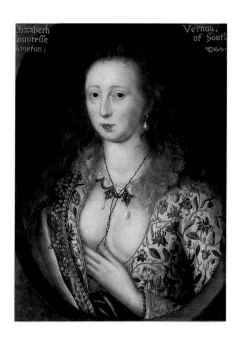

Elizabeth Vernon was the daughter of John Vernon of Hodnet in Shropshire and Elizabeth, sister of Walter Devereux, 1st Earl of Essex. She was a Maid of Honour to Queen Elizabeth I. She married Henry Wriothesley, 3rd Earl of Southampton (1573–1624) in secret during the summer of 1598. This, together with her subsequent pregnancy, infuriated the Queen, who had Southampton imprisoned in the Fleet within weeks of the Countess giving birth in November that year. Elizabeth Vernon was a fashionable lady of considerable status and there is a small full-length portrait of her at her toilet that similarly shows her with her hair worn long (but not greying) and dressed in the latest embroidered jacket decorated with flowers that approximate botanical exactness.

This portrait also shows Elizabeth Vernon in a private *persona*, her hair worn long in a manner that was still fashionable in portraits of c. 1615. Comparable portraits showing this hairstyle are those of Lady Anne and Lady Elizabeth Pope (R. Strong, *The English Icon*, London and New York 1969, 239, 252). The gesture of her left hand held to her bosom is private and affectionate, rather than provocative. Her over bodice jacket is superbly painted and captures precisely the fashionable status associated with botanical specimens in any form at this time, c. 1615. The flowers include Sweet Briar or Eglantine (*Rosa rubiginosa*) for beauty and wild pansy (*Viola tricolor*) for faithfulness. Columbine (*Aquilegia vulgaris*) was emblematic at this time of Christ's Passion, the Holy Trinity and Salvation. The flowers are not botanically precise, having been modified by the artist for decorative effect. The delphinium, for example, bears the wrong leaves and is on the same stalk as the wild strawberry. Other flowers are shown upside down.

These were all common flowers in Britain at this time, both in the wild and cultivated in gardens. Their identification today by comparison with modern examples is not a sure science, as those varieties we know may well have been cultivated to their modern appearance. The *Delphinium ajacis* (introduced into Britain in about 1573) has a traditional association with mourning in Greek legend from the story of Ajax, which might seem to date the choice of flower to the year of the death of the 3rd Earl. While common fashionable accoutrements of this period, such a selection of emblems may well reflect the Countess's personal choice of decorative motif, denoting her devotional bond to her husband, reinforced by the gesture of her hand to her breast.

The wild strawberry (*Fragaria vesca*) is also included among the flowers decorating Elizabeth's jacket. When painted while in fruit, the flower represented the first fruit of the year, symbolizing virtue attained by those who accomplished good deeds with humility. The choice of this fruit, ripened by the sun, in adorning the body, would have been understood at this time both as a symbol of spiritual growth and as an allusion to sensuality and eroticism, to fertility and abundance, symbolic of physical and spiritual love. It is tempting to tie the commission of this portrait to an important moment in the relationship of the 3rd Earl and the Countess. However, it is by no means the case that this highly fashionable attire should relate either to their marriage or the death of the 3rd Earl in 1624: it is not necessarily a portrait representing mourning. It should perhaps rather be read as an illustration of the Countess's taste as a fashionable lady who consciously bedecked herself with flowers, making it unnecessary to be portrayed with any other form of emblem (Heilmeyer, 28). AM

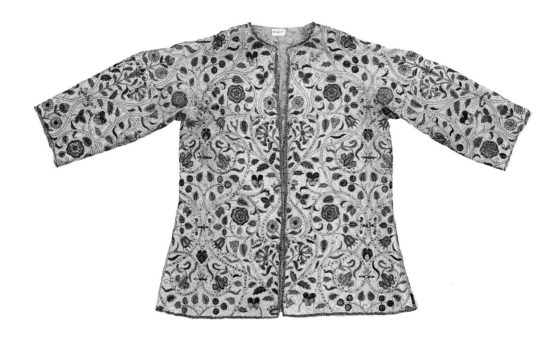

Woman's embroidered jacket, early 17th century

English

Wool and silk on silk ground, 68 x 126 cm

Victoria and Albert Museum, London

The jacket is embroidered with a number of flowers commonly found on female costume of the period with a varying degree of emblematic significance, as can be seen in the portrait of *Elizabeth Vernon, Countess of Portsmouth*.

Stylised red and white roses had been central to sixteenth century Tudor dynastic symbolism. Their role as emblems also developed to represent marriage, fecundity and motherhood – the red rose symbolised childbirth and the white rose a mother's milk.

Columbine (*Aquilegia*) was sometimes seen to signify sorrow due to its often dark purple appearance, while in a catholic cultural context seven columbine flower-heads could be used to represent the seven sorrows of Mary as well as being symbols for the Holy Spirit. In this case seven flowers would represent the seven gifts of the Holy Spirit: power, riches, wisdom, might, honour, glory and blessing.

By the early seventeenth century it is uncertain whether such decoration would have had a specific symbolic purpose. It is more likely that the rose and columbine on this jacket, together with the other flowers, which include honeysuckle, irises or lilies, daisies and pansies, are the commonplace fashionable floral motifs of a woman adorning herself in the manner of a modern Flora. Nevertheless, they may still have subtle emblematic intent with overtones of classical and pastoral imagery. Edmund Spenser (1552–99) introduces many of these flowers as adornments for Elizabeth I in his poem *The Lay to Eliza*. John Fletcher (1579–1625) makes a more general connection in his poem *Love's Emblems* and Shakespeare uses honeysuckle as the principal symbol of a lover's embrace in *A Midsummer Night's Dream* as the enamoured Titania says to Bottom 'Sleep thou, and I will wind thee in my arms./ …So doth the woodbine the sweet honeysuckle / Gently entwist' (Act 4 Scene 1). CG

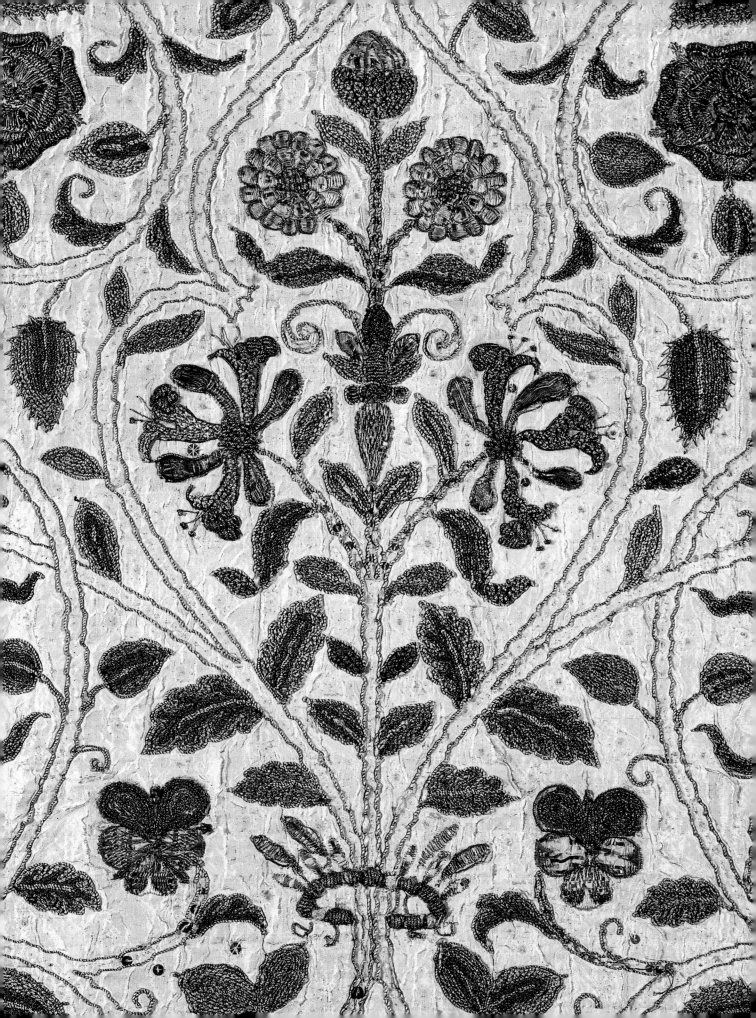

Jacket

spring/summer 1995

Hussein Chalayan (b.1970)

Photographically printed paper with floral design

Victoria & Albert Museum, London

Hussein Chalayan is one of the major fashion designers working in Britian today. Born in Turkish-owned Cyprus but educated in England, his 1993 graduation show from Central St Martin's School of Art propelled him into the limelight, as he showed decomposing clothes – garments he had buried in his back garden. In *Vogue*, January 1994, he declared 'I am not interested in fashion' and yet remains at the forefront of contemporary British fashion. His clothes – as this jacket illustrates – are technically and conceptually complex as well as stylish and wearable.

Chalayan has a fascination with exploiting the technical boundaries of fashion. The jacket is one hundred per cent paper, but has been treated so that it remains unrippable and can even be cleaned: a label inside advises the wearer to 'wash at 20 degrees, do not iron, do not tumble dry'. Stylistically it is reminiscent of a riding jacket and, although the tailoring is intricate, the overall effect is one of elegant simplicity. The combination of the style and decoration gives the jacket a very 'English' look, the fresh and vibrant colours reminding the wearer of a country garden and of that most traditional of pursuits – gardening.

The flowers themselves are those that correspond exactly with the fashion season – spring/summer. Amaryllis, nerine, wild tulips, bearded irises, poppies and alliums have been painted, then photographed and finally printed around the base of the jacket. Complete with bulbs and even clods of earth, they seem to have just been pulled out of a flowerbed. Their appearance is reminiscent of early depictions of plants in herbals such as John Gerard's *Herbal, or the General Historie of Plants* of 1597. As a whole the jacket certainly recalls, plays on and develops the notion of adorning clothes with emblems taken from such books. Rather than simply creating clothes for a modern day *Flora*, Chalayan seems to have used far more specific references to present a specifically botanical identity for the wearer. The combination of paper and floral decoration too adds a further element; fragile and transient in nature, both material and adornment are here made permanent.

JK

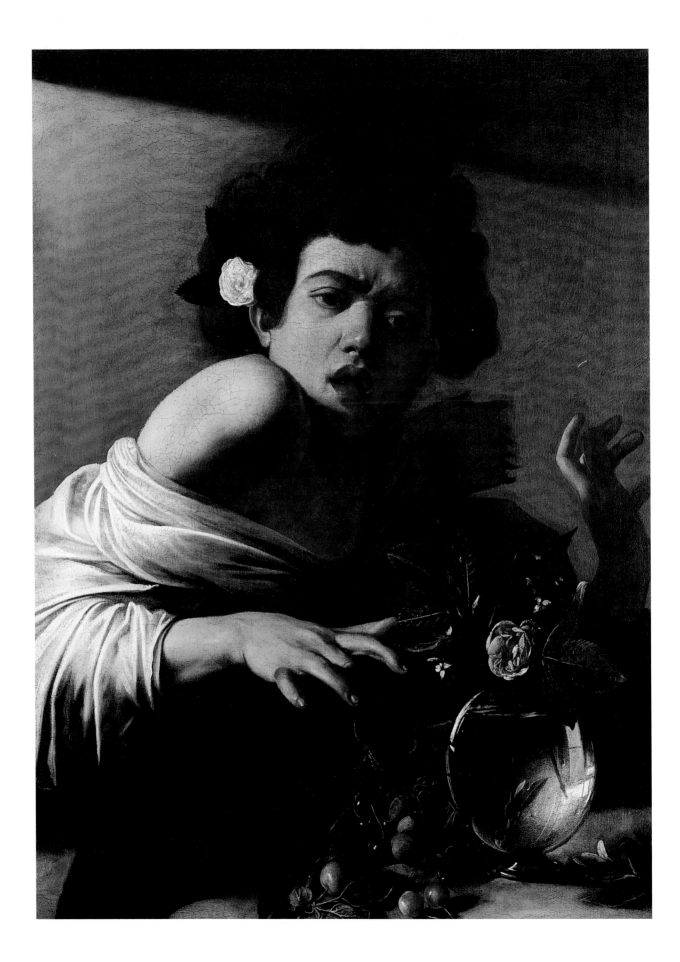

Boy bitten by a lizard

Michelangelo Merisi da Caravaggio (1573–1610)

Oil on canvas, 66 x 49.5 cm

National Gallery, London

Michelangelo da Caravaggio's ability to combine naturalism with a dramatic intensity is clearly illustrated here in an image which invites the onlooker to question the traditional values associated with life and beauty as depicted in art. The young boy is very likely a mirror image of the artist himself, while the danger that lurks in an apparently innocent vase of flowers is dramatically revealed.

Caravaggio here transforms a traditional 'fanciful' subject into an allegory of death or – at least – danger in life. The flowers symbolize the bloom of youth cut short, with danger lurking in even the most simple and beautiful vase of flowers. The lizard is often found in European paintings symbolizing 'vanity' or the transience of life, while in Chinese folk medicine an unguent made from powdered lizard and cinnabar could be used to test virginity or marital fidelity in the Chinese Court. This ancient association may or may not have been in the mind of the

artist, but it is a mirror to the conventional symbolism of the cut rose more readily understood today. The red rose was traditionally associated with Venus and her attendants (the three graces), but also with Flora, the Italian goddess of flowers, symbolizing love and beauty. These feminine attributes are here ascribed to the young boy, who wears a white rose in his hair, at this time a symbol of virginity.

Caravaggio's pictures of this type found favour with his patrons in Rome, and there is more than one version of this subject (notably Florence, Longhi Collection). His overtly sensuous approach to the depiction of youth found expression in his sensual portraits of the young god Bacchus which also date from this period in his work. The arresting nature of his art invites such a sense of identification from the onlooker that writers have consistently sought comparisons with Caravaggio's personal life when writing about the power of his paintings to move us. AM

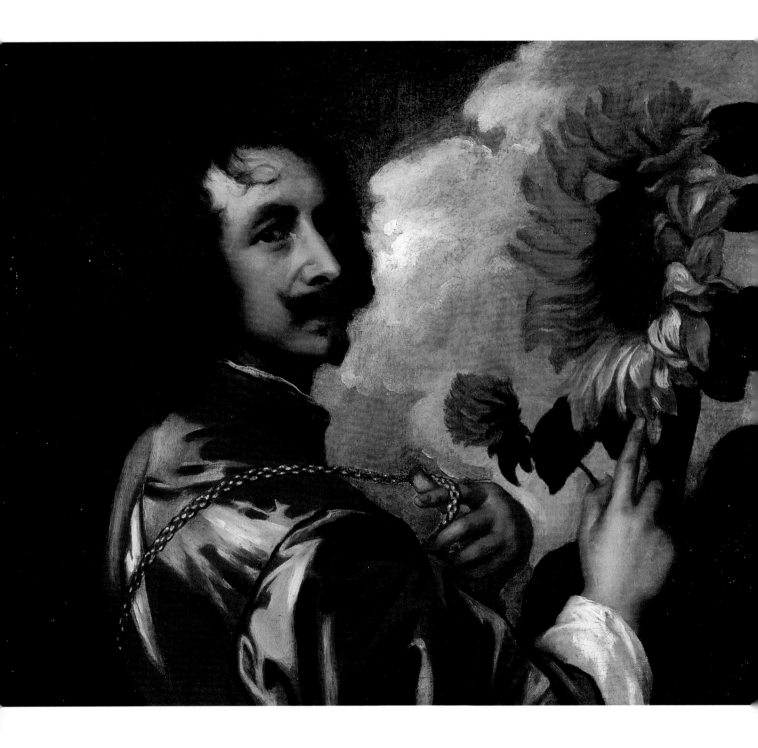

Self-Portrait with Sunflower, 1632–33

Anthony Van Dyck (1599–1641)

Oil on canvas, 60.3 x 73 cm

By kind permission of His Grace the Duke of Westminster O.B.E, T.D., D.L.

and the Trustees of the Grosvenor Estate

This extraordinary and iconic image is the epitome of an artist's identification with the symbolism of flowers in art. The artist, with reflective self confidence, draws attention with one hand to the heavy gold chain worn over his right shoulder, while with his right hand he points to a double-petalled sunflower, which faces him with equal status within the composition. The effect is a visual metaphor that still has the power to generate meaning beyond the artist's own time.

The gold chain is a key element in the image. Van Dyck had been presented with 'a chain and gold medal of One Hundred and Ten pounds value', for which the Lord Chamberlain issued a warrant on 20 April 1633. The medal is not shown and it is not necessarily the King's chain: the chain and its links could equally refer to the continuity of the art of painting, as each artist learns from the previous generation, an idea common at this time.

The existence of good late seventeenth-century versions of this enigmatic image which repeat the rich palette (private collection and Ham House) is evidence of the longevity of this most explicit image of identity. Van Dyck's identification with the sunflower clearly indicates a self-knowledge that he was prepared to share with his patron King Charles I and with the Court. The fact that this iconic image was replicated conceivably within living memory of Van Dyck himself indicates the lasting power of this image to move us and for an artist

to be identified with the master and patron. The image was etched by Wenceslas Hollar (1644), and dedicated to John Evelyn as a patron of painting, further extending the influence of this potent image beyond the artist's own self image.

The sunflower is a prime example of the visual vocabulary to which artists have turned to express their loyalty: pride, devotion and – in the case of Van Dyck – friendship and inspiration. The sunflower is native to northern Mexico and southern Canada, a source of body paint for native American Indians before the birth of Christ. The flower takes its name from its heliotropism – its method of growing towards sunlight – and it was for this reason that it became associated with the sovereign and loyalty. In Christian iconography the sunflower signified devotion to the Catholic Church, while early botanists and emblem writers had always endowed it with meanings associated with human or divine love, such as the soul seeking illumination. Van Dyck also introduced a sunflower, this time fading and dying, into his portrait of *Sir Kenelm Digby in mourning with a Sunflower* (private collection), which also survives in a number of versions. This almost certainly relates to the recent death of Digby's wife, Venetia, but equally could refer to Digby's loyalty to the King (C. Brown and H. Vlieghe, *Van Dyck 1599-1641*, Antwerp and London 1999, pp. 244–45; E. Chaney and G. Worsdale, *The Stuart Portrait Status and Legacy*, Southampton City Art Gallery 2001, pp. 37–38). AM

Aesthetic double-sided teapot
patented 21 December 1881

Designed by R. W. Binns and James Hadley for the Royal Worcester Porcelain Co.

Porcelain, Height 16 cm

Hanley Teapot Collection

Produced by Royal Worcester, this teapot satirized the exaggerated manners and affectations of the aesthetic movement, unashamedly poking fun at the sexual ambivalence of figures such as Oscar Wilde. It simultaneously attacked Charles Darwin's still revolutionary theories of evolution (*Origin of Species* had been published in 1859 and *Descent of Man* followed in 1871).

The teapot is inscribed under its base 'Fearful consequences through the laws of Natural Selection and Evolution of living up to one's teapot'. This adapts a caricature by George du Maurier published in *Punch* on 30 October 1880. Entitled *The Six-Mark Teapot*, it shows an Aesthetic Bridegroom, clearly based on Wilde, discussing a blue-and-white teapot with his bride. He enquires 'It is quite consummate, is it not?' to which his 'Intense' bride replies, 'It is, indeed! Oh, Algernon, let us live up to it!'. This satirical comment on the contemporary mania for collecting Chinese and Japanese blue-and-white porcelain picked up on Wilde's own earlier remark concerning his relationship to the Aesthetic Movement, 'I find it harder and harder every day to live up to my blue china'.

The male and female aesthetic figures on the teapot wear a sunflower (*Helianthus*) and an arum lily (*Zantedeschia aethiopica*) respectively. Sunflowers and lilies had become synonymous with the Aesthetic Movement in general and Wilde in particular. They repeatedly featured as a visual shorthand in du Maurier's caricatures in *Punch*. In 1877, while still at Oxford, Wilde had completed a series of questions in a Confessions Album declaring his favourite flower to be the 'Lilium Auratum' or Japanese lily. This choice succinctly combined the aesthete's symbol of the lily with a taste for all things oriental. He adopted the sunflower and lily almost as a personal signature (Charlotte Gere with Lesley Hoskins, *The House Beautiful, Oscar Wilde and the Aesthetic Interior*, London 2000, 93) and in his lecture on 'The English Renaissance of Art' praised

the sunflower for its 'gaudy leonine beauty'. In fact, following the publication of his first collection of poems, Wilde had actually been portrayed as a sunflower in a *Punch* cartoon of 25 June 1881.

The male figure on the teapot is closely based on the character of Reginald Bunthorne from Gilbert and Sullivan's comic opera *Patience*, a satire whose targets, as the impresario Richard D'Oyly Carte expressed it, were the 'unmanly oddities which masquerade' as the 'true aesthetic spirit' (Gere 28). *Patience* had opened at the Opéra Comique in London on 23 April 1881, before transferring to the Savoy Theatre later that year. Bunthorne, a 'fleshy poet', was played as a combination of Wilde and the painter Whistler.

The arum lily on the female figure clearly identifies it with Archibald Grosvenor, one of the other male characters from *Patience*, who wears a similar buttonhole, but in the case of the teapot it has now evolved into a figure more reminiscent of Sarah Bernhardt. Wilde had cast an armful of lilies at Bernhardt's feet when she arrived at Folkstone in 1879 and had played court in the same exaggerated manner to Lillie Langtry.

The sexual ambiguity alluded to by the teapot would become tragically explicit in Wilde's downfall in 1895. Wilde had flirted with danger at the opening night of *Lady Windermere's Fan* when he had encouraged a number of friends to sport green carnations as buttonholes. When asked what they meant Wilde had apparently replied 'Nothing whatever, but that is just what nobody will guess' (Richard Ellmann, *Oscar Wilde*, London 1987). However, the connection was firmly made in 1894 when Robert Hitchens published a thinly veiled satire of Wilde's relationship with Lord Alfred Douglas under the title *The Green Carnation*. This association would be picked up by Noel Coward in his song *Green Carnation* from *Bitter Sweet*, first performed in 1929. CG

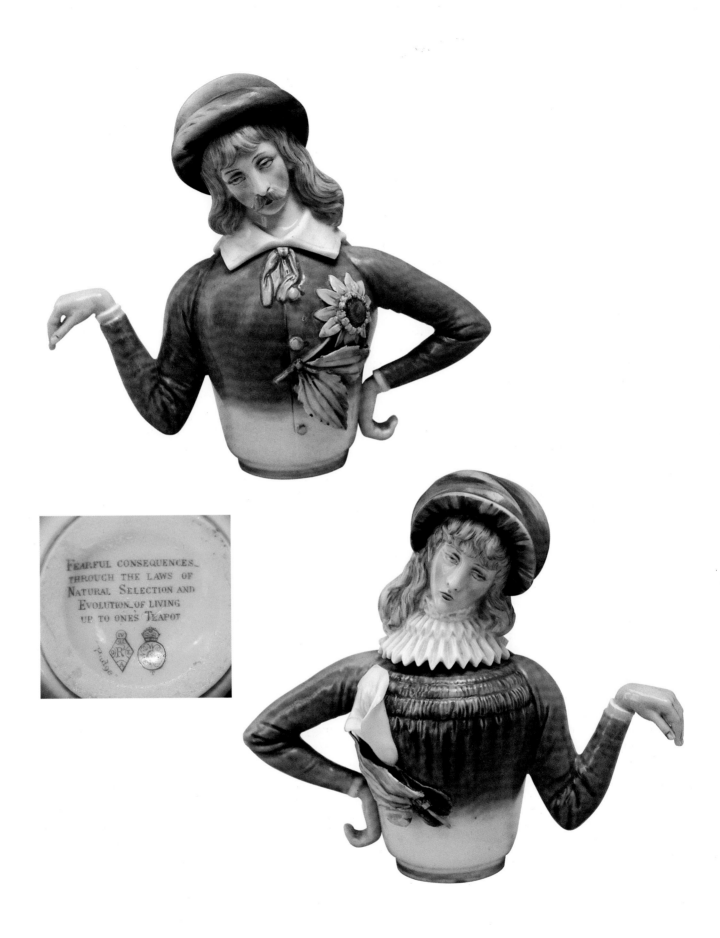

FEARFUL CONSEQUENCES
THROUGH THE LAWS OF
NATURAL SELECTION AND
EVOLUTION OF LIVING
UP TO ONE'S TEAPOT

3

Tulipomania

The most extraordinary demonstration of the power of flowers over the mind of mankind took place in Holland during a brief period in the 1620–30s. The story of the speculative trade of the tulip has been told many times: today it acts as a reminder of how one society can become so obsessed with a single commodity that it can cause its own economic downfall. Instead of following the traditional market of stocks and shares Dutch traders sought to maximize their profits by speculating on the reproduction of highly prized varieties, notably the flamed and striped blooms which were the product of horticultural propagation. It was not understood that wealth and status were being wagered on the cloning of viruses. The noble *Semper Augustus* (red flames on white), for example, was highly prized, while growers developed the practice of naming varieties with suitably heroic titles. These were invariably male and aggrandized with names such as *General Bol* after the Haarlem grower Pieter Bol. Female attributes were not ignored: one Dutch poet compared the *Tulipa clusiana*, with its carmine-tinted white petals, to the 'faint blush on the cheek of chaste Susannah' (S. Schama, *The Embarrassment of Riches*, London, 1987, 354).

The tulip, a symbol of love, originated from Persia, but in northern Europe it underwent a series of identities of association. Tulips were laden with emblematic meaning but, as with all such flower symbolism, meanings change through time, or as a result of changing contexts. At first the tulip was the most prestigious flower, emblem of wealth: later it came to represent the ultimate folly. At the height of its fame Calvinist preachers scorned its association with elegant extravagance and the vanity of earthly devotion to its beauty. This view was apparently vindicated by the financial crash of 1636–37.

At its height the speculative mania resulted in a single bulb of the *Semper Augustus* fetching a thousand guilders. At first the tulip was simply a costly flower, produced by gentlemen botanists or a small number of professional growers. A great number of tulip books, effectively sale catalogues produced for bulb dealers during the Tulipomania craze, appeared in Holland in the 1630s. As more and more buyers and growers entered the market, the inevitable crash followed. The Dutch church and state reacted in horror and much moralizing ensued: a common printed (and painted) image in 1637 was that of Flora being drawn in a chariot of Fools.

Many of the works of art featuring tulips that survive today testify to the abiding power of the bloom to represent wealth and status for the owner – in Europe and in the East. Yet the tulip, in its perceived rarity, could represent not only wealth, but also vanity and extravagance – even foolishness – during the course of the seventeenth century. In the eighteenth century the tulip became a hobby flower for florists (Pavord, 131, 212) and in the twentieth century the emblem of Holland, all evidence of excess forgiven. AM

Iznik Dish, Fritware, with underglaze painting, c.1560–1600, (detail)

Dish

Turkey, Iznik; c.1560–1600

Stone paste body, with underglaze painting, Diameter 30.2 cm

Victoria and Albert Museum, London

The manufacture of a new and superior type of Ottoman ceramic began in the second half of the fifteenth century, mainly in the small town of Iznik, south-east of the capital, Istanbul. In the initial stages, these products were intended for use in the Ottoman court, and the imperial design workshops provided the potters with the rich patterns with which the ceramics were decorated. In the sixteenth century, Iznik wares began to be made for a wider market, and they were exported to non-Ottoman Europe, where they were highly valued. The imperial court, however, held imported Chinese porcelains in greater esteem. These were kept in the Topkapi Palace treasury and survived a fire in 1574 that destroyed the imperial kitchens, and with them the Iznik bowls, dishes, bottles, ewers, carafes, jars and other items that were used in the everyday preparation and serving of food and drink. Fortunately, other examples survived elsewhere.

The body of Iznik wares is rich in ground quartz, which makes it hard and glassy and gives it a more porcelain-like appearance. The other main ingredient, used in relatively small amounts, was a local white clay and a glaze mixture, which served to bind the quartz particles. The slip in which the body was dipped before firing provided the remarkable, clear, white ground for the decoration. At first Iznik wares were decorated in underglaze blue only, but a wider range of colours was developed, allowing the potters to execute striking poly-chrome decoration, particularly in styles reflecting the court's passion for flowers (Nurhan Atasoy & Julian Raby, *Iznik: The Pottery of Ottoman Turkey*, London, 1989, pp. 14-18).

Kara Memi, the chief artist at Sultan Süleyman's court, is credited with introducing the use of naturalistic flower motifs in illuminated manuscripts.(Atasoy & Raby, 71). Floral designs were quickly made up for the potters of Iznik. In the Ottoman empire, as in the other Islamic empires of Safavid Iran and Mughal India, the form of these patterns was influenced by European herbals, for which there is striking testimony in a copy of a plate from a seventeenth century English herbal done by an Iranian artist (Basil Gray, 'An album of designs for Persian textiles' in *Studies in Chinese and Islamic Art*, London, 1985–87, 256–63). On Iznik pottery the most common motifs used were the flowers found in Turkish gardens and the open country: tulips, roses, hyacinths and carnations. Tulips were particularly prized, especially the varieties with long, elegant pointed petals; the emperors had bulbs from the wild planted in the imperial gardens of the Topkapi Palace in Istanbul, and cultivated other species, including Dutch and Persian imports. The Holy Roman Emperor's ambassador to the Turkish court wrote of the flowers to be found everywhere and the native passion for flowers that encouraged extravagance in the purchase of bulbs. The tulip he described as having 'little or no scent, but it is admired for its beauty and the variety of its colours.' (*Atasoy & Raby*, 71)

By the time that the new floral style was adopted for Iznik wares, a new colour scheme had been developed that included a vibrant relief-red, the most difficult ceramic colour to achieve successfully. The discovery of how to produce this colour, by the use of a thick slip, allowed the tulip and the rose to take their place in the new decorative repertoire of naturalistic flowers. Yet, while they were often naturalistically represented in the new red, they were also represented in a non-naturalistic manner, as with this dish, where the tulips are blue, with fritillary-like red spotting. There is no evidence that the flowers had any religious significance at this time, although later flowers were used in this way. DC

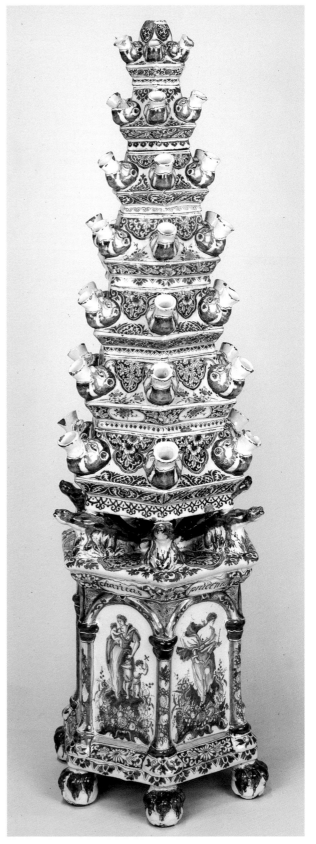

Pyramid flower vase

Tin-glazed earthenware, painted in underglaze blue

c. 1690

Mark, AK for Adriaen Kocks, 107 x 32 cm

The Devonshire Collections, Chatsworth

The 4th Earl and 1st Duke of Devonshire (1641-1707) commissioned vases, urns and pyramid flower vases from the Delft potter Adriaen Kocks for Chatsworth House. From about 1900, it was thought that these pyramid vases were for the sprouting of tulip bulbs, and a feature of Tulipomania. However, they were intended for the display of cut flowers: the base supports seven stacking tiers, each with a tray to contain water, from which the stems of flowers were supported by the cylindrical spouts. They were certainly used for cut tulips during the spring, but probably showed simplified arrangements of garden flowers at other times of the year. Although Dutch flower paintings suggest that mixed arrangements of flowers in interiors were commonplace, these paintings were primarily allegorical. It seems that flowers were set out for special occasions only (Ronald Brouwer, 'Turkish tulips and delft flowerpots' in M.Roding & H.Teunissen, *The Tulip- A Symbol of Two Nations*, Utrecht & Istanbul, 1993, 25–39).

Tin-glazed earthenware was made at Delft and other centres in Holland from the beginning of the seventeenth century. The success of the manufactories was derived from their ability to respond to a new demand for tableware and ornamental wares for the fashionably decorated interiors of Baroque palaces. It was also linked to the Dutch consumer's need for sound investment and conspicuous display in a rapidly expanding economy (The National Gallery, *Art in Seventeenth Century Holland*, London, 1976, 14–15). Chinese and Japanese porcelain was also first exported in quantity to Europe during the same period, particularly by the Dutch East India Company and as greater quantities were available in Holland, it became fashionable to display porcelain – particularly blue and white – in massed formal arrangements in Dutch palaces. Delftware manufacturers made vases, jars or urns for the same purpose – to embellish

empty hearths during the summer when they were often filled with flowers (natural or silk), and smaller items were made for mantel-shelves, tops of cabinets or door-cases. The fashion for these arrangements spread from Holland to the courts of France, England and Germany, and delftware was as valued as Oriental porcelains (Peter Thornton, *Authentic Décor: The Domestic Interior 1620-1920*, London 1985, 49, 60).

The form of pyramid flower vases seemingly alludes to Chinese pagodas, which were known from Chinese porcelain patterns. At first, delftware directly imitated Chinese imports with its underglaze blue painted patterns on a white ground. By the end of the seventeenth century, European ornament patterns were more common. These included the lacy lambrequins that are painted between the spouts of the Chatsworth pyramid, the lion paw feet that support it, and the figures of six of the seven Virtues that are painted in the niches of the hexagonal base. The Dutch had a great liking for scenes of Roman virtue (as well as Bible stories) that were derived from engravings by contemporary Dutch artists, and these figures almost certainly come from such a source. The Virtues chosen for the vase are Prudence, Faith, Fortitude, Hope, Justice and Charity, each appropriately depicted standing in a bed of flowers. Commissioned pieces, like the pyramids for Chatsworth, could also be painted with coats of arms.

Mary II brought the court fashion for massed blue and white ceramics to England. Pyramid flower vases were supplied to the garden room at Het Loo, her palace in Holland; more were ordered as part of the furnishing of the new interiors at Hampton Court. Other pyramid vases survive at Uppark, Dyrham Park and Blenheim Palace, where they were commissioned for the 1st Duke of Marlborough (ed. Gervase Jackson-Stops, *The Treasure Houses of Britain*, Washington & New Haven 1985, 172). DC

Study of Tulip with Delphinium and White Admiral, c. 1660–85

Nicolas Robert (1614–85)

Gouache on vellum, 33.4 x 21.5 cm

The Burghley House Collection

Little is known of the early life and artistic training of Nicolas Robert, who became one of the most influential botanical artists of his period. He first comes to light with the successful publication of a printed florilegium in Rome in 1640, the *Variae ac multiformes Florum species depressae ad vivum*. Several important commissions followed, including work for the Baron de St Maur and Gaston d'Orleans, younger brother of King Louis XIII. Gaston d'Orleans employed Robert to paint a series of watercolours on vellum depicting the various flowers and animals in the gardens of his chateau at Blois. After Gaston's death in 1660, the collection went to his nephew, by then King Louis XIV, who promptly employed Robert as '*peintre ordinaire du Roy pour la miniature*'. The French court had a tradition of supporting the natural sciences, part of which included the employ of a botanical artist; Robert was to be the third.

Continuing to paint on vellum, Robert established his own tradition at the court, his works for Gaston and Louis XIV forming the basis of a huge collection of botanical works on vellum known as 'les vélins du Roy' (now in the Bibliotheque Nationale, Paris). The Burghley House folio, from which this study is taken, is almost certainly part of this collection and includes a range of botanical studies, ten attributed to Robert. An inscription on the flyleaf states: 'This book was given to Henry Marquess of Exeter by Ld. Gwyder Sep:23.1801 / It came out of Lewis ye 15th Library'. The reference to the Library probably refers to the Bibliotheque de Roi, established by Louis XV, rather than the King's personal library, yet how a part of *les velins* came to be in the possession of an English aristocrat remains a mystery. During the French Revolution the collection was moved from the Palais de Louvre to the Bibliotheque; perhaps it was during this move that Baron Gwydir was able to acquire the folio.

The quality of the work is superb. Each closely observed flower is made from an 'infinity of finely hatched strokes' (Blunt, 119) in the manner of miniature work. While the device of placing a single stem against a plain background derives from early herbals, Robert has added a butterfly, providing a sense of scale and of movement within the study. The choice of flowers is puzzling and it is tempting to read a symbolic meaning in the study. Robert's work for the Baron de St Maur involved the emblematic use of flowers and it is possible there are elements of this here. Following the excesses of the Tulipomania craze in the early seventeenth century, the tulip had become a well-known symbol of man's folly and the emptiness of material gain. Added to this, butterflies were traditionally used in art to represent death and resurrection, a practice that extended to the illustrative work of natural historians such as Maria Sybilla Merian. Has Robert incorporated a subtle but definite element of *vanitas*? He has certainly created a work that has both scientific and artistic appeal, combining both observation and elegance. JK

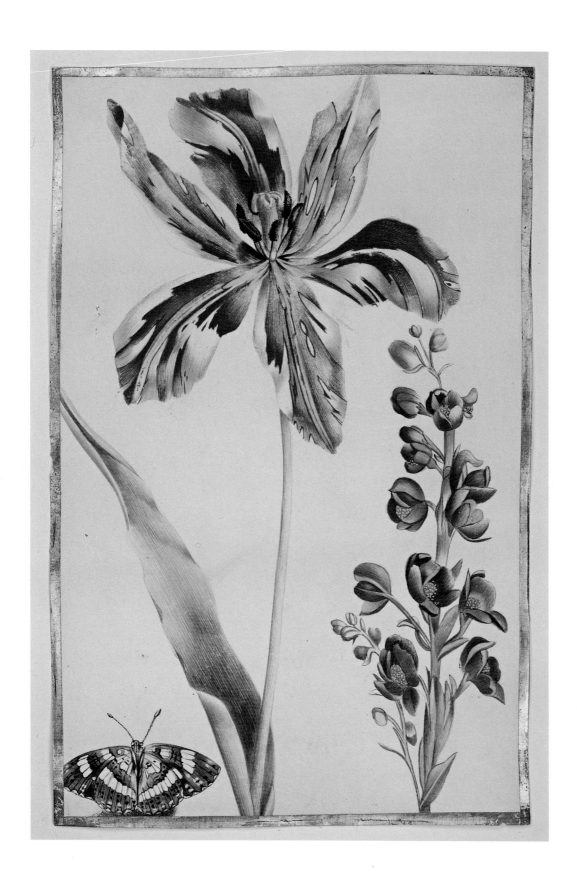

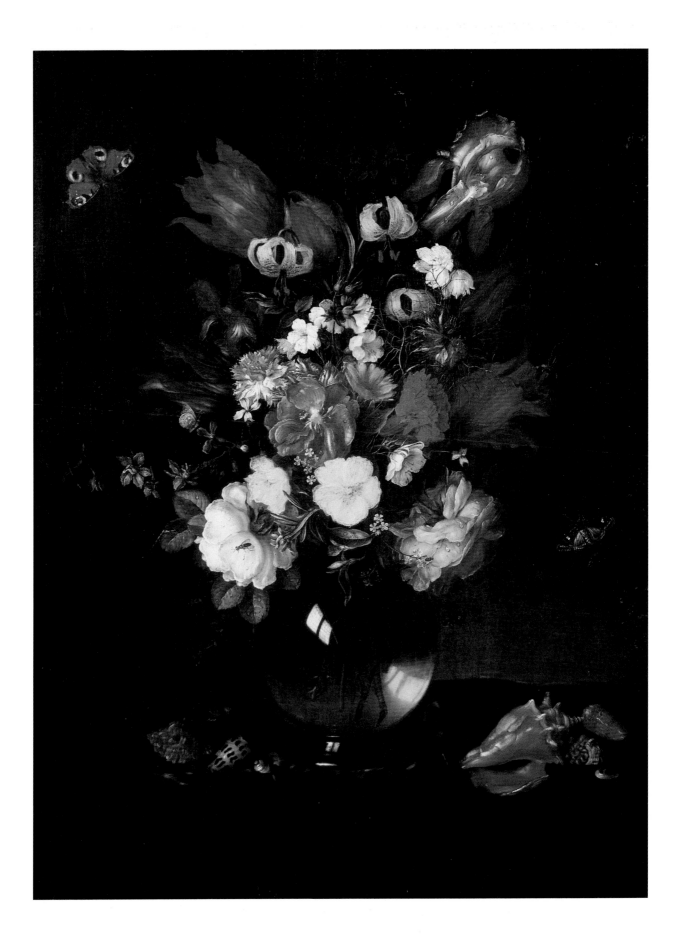

Still Life of Flowers, Shells and Insects in a glass vase on a velvet cloth, 1655

Pieter van de Venne (1603–57)

Oil on canvas, 66 x 50.7 cm

Guildhall Art Gallery, Corporation of London

This is a masterpiece by an otherwise little-known painter from The Hague, the brother of the more celebrated Adriaen van de Venne (1589–62). Born in Middelburg in 1603, the artist moved to The Hague where he studied under Evert Crinjsz van der Maes (1577–1656). In 1656 he became master of the Pictura Confraternity in The Hague. His *Vase and Flowers* is a classic composition, distinguished by the inclusion of a number of specific species of flower which typify the pride of ownership and the display of wealth, yet contain references to the vanity of human pride on this earth.

Key elements to the left and right of the composition are the flamed tulips. Dated 1655, the painting represents a moment some twenty years after the craze for Tulipomania, a bubble that was to burst with the financial crash of 1636–37. At the centre of the composition is a white mallow (*Malva neglecta* or conceivably hollyhock from the same family). The mallow in Christian symbolism at this time represented healing and resurrection: in the nineteenth century it came to represent a request for forgiveness. The other key blooms in the composition are the white bearded iris, symbolic of faith and purity and

the Turk's cap lily (*Lilium martagon* also called Pyreneciaen lily). Smaller blooms no less significant include the marigold (*Calendula officinalis*) for death, forget-me-nots (*Myosotis*) for constancy and faithfulness and nigella (*Nigella sativa*), symbolic at this time of martyrdom (specifically that of St Catherine due to its wheel-shaped leaf), but also associated with love and rejection (Heilmeyer 38,54,86).

Without knowing the original circumstances surrounding the painting of this still-life it is difficult to conclude that this group of blooms has a specific meaning, perhaps associated, for example, with a particular relationship. Its generic meaning remains clear, however, as the additional symbols that the artist includes all have traditional *vanitas* connotations. The choice of a glass vase refers to the fragility of life, while the numerous shells and insects (including a peacock butterfly to the left), all painted with a high degree of naturalism, refer to the brevity of life. The rich velvet cloth demonstrates worldly success, as do the exotic shells, but the onlooker is also meant to grasp the vanity of these earthly things.
AM

4

Anatomy of Flowers

'The greatest flower artists have been those who have found beauty in truth; who have understood plants scientifically, but who have yet seen and described them with the eye and the hand of the artist' (Wilfrid Blunt, *The Art of Botanical Illustration*, London 1950; revised and updated by William T. Stearn, Antique Collectors' Club, 1994).

It was the eighteenth century, the age of Captain Cook's voyage in the *Endeavour* collecting new botanical specimens and of botanists like Sir Joseph Banks and illustrators such as Georg Ehret, that was to witness the greatest period in the botanical illustration of flowers. The science of botany was becoming increasingly precise and sophisticated: it was Princess Augusta who established the Royal Botanical Gardens at Kew in 1759. Carl Linnaeus (1707–78), a Swedish doctor, scientist and one of the most important naturalists of the period, had developed in the 1730s a system for classifying plants. The Linnaean System of classification according to the number of male and female sexual organs would be widely used in botany for the next half century. Mrs Mary Delany in her paper flower collages recorded this adoption of the Linnaean system, taking great care to include the correct number of stamen and styles in each of her pictures. The eighteenth century also witnessed the establishment of a British institution that was to be pivotal in the popular dissemination of the science of botanical illustration: the *Botanical Magazine*, founded by William Curtis in 1787, continued in publication until 1983.

The eighteenth-century preoccupation with the scientific examination of flowers, their botanical description and classification through close observation, dissection and accurate depiction, has roots in the classical world as ancient as the symbolism with which they became so often associated. Early herbals were predominantly created to identify useful medicinal plants and, because of this functional purpose, were highly realistic if not always entirely accurate from a strictly botanical point of view. Gradually, however, poor copying during the medieval period led to debased and overly stylised images which in some cases were little more than decorative embellishments of the text (Blunt, 23).

It was the Renaissance that saw a rebirth of naturalism with artists such as Da Vinci, Dürer and Bellini producing images of startling realism. Their influence is increasingly seen in herbals of the late fifteenth and sixteenth centuries, although certain fanciful notions such as the anthropomorphic representation of both the Mandrake and Narcissus proved stubbornly long lived. The growing naturalism of this period was supported by reproduction through the newly developed method of the printed woodcut and later by etching and engraving. The primary purpose was still to assist in identifying specimens for medicine.

In contrast, the second half of the sixteenth century saw an increasing interest in floriculture which resulted in a vast expansion in the number of available plants through seed raising and selection. This was further increased by a growing taste for importing foreign plants. The tulip, oriental hyacinth and crown imperial all found their way from Turkey during this period and plantsmen such as John Tradescant would continue this process through the first half of the seventeenth century. As a result, botanical illustration came to describe the exotic and the beautiful as well as the simply useful. CG

Papaver somniferum, The Opium Poppy, 18 October 1776, Mary Delany (detail)

Lucy Ebberton

George Knapton (1698–1778)

Oil on canvas, 76.5 x 64.1 cm

The Trustees of Dulwich Picture Gallery, London

George Knapton is chiefly remembered for his series of portraits of members of the Society of Dilettanti, of which he was a founder member in 1736. Knapton produced a total of twenty-three members' portraits of this group of literary connoisseurs and convivial artists, many in fancy dress with symbolic overtones.

Knapton's portrait of Lucy Ebberton, a far cry from these portraits, is particularly successful and the sensitivity to surface texture and the symbolism of flowers suggests that the artist was deeply committed to this commission. There is a considered concentration about the portrait that demonstrates a care for detail, painted with finesse and not unduly laboured. The sitter's identity was recorded by Horace Walpole on his version of a print based on this otherwise anonymous portrait: 'Lucy Ebberton – afterwards the wife of Capt. Greeg of the Marines by whom she had three or four children. She resided sometime at Blandford and afterwards removed to Exeter. Barton who kept the London Tavern in Poole was her uncle'.

Her costume tell us rather more of Lucy. The style of her informal morning gown is typical of the late 1740s and is appropriate to her adopted guise as a contemporary Flora in a pastoral setting. The large floral pattern decorating her dress denotes a magnificent example of the latest Spitalfields silk. The silk designers at Spitalfields specialized in developing designs based upon published natural history sources, such as the botanical illustrations of Maria Sybilla Merian. One example of a designer who shows this influence is Anna-Maria Garthwaite, who included the newly introduced magnolias in a number of her silk designs from around 1741. Equally, Gurle's nursery in nearby Moorfields specialized in flowering shrubs such as honeysuckle, jasmine and lilac, all specimens which found their way into the silk designs (Clare Browne, 'The Influence of Botanical Sources on Early 18th-Century English Silk Design', *18th Century Silks: The Industries of England & Modern Europe*, Abegg-Stiftung, Riggisberg, 2000).

Lucy wears very elaborate paste jewellery, as if for a particular occasion. Her latter-day accoutrements, notably her basket of spring flowers, imply a special message or occasion, elevating her beyond any suggestion that she may be a simple shepherdess. They are also typical of the kind of fanciful portrait of this period that would associate the sitter not only with a season but also with the senses: in this case Lucy's fresh blooms suggest simply the fresh scents of spring, making manifest those associated with the blossoms on her dress. The flowers are not readily identifiable, being based upon real flowers but enhanced by artistic license. The exception is the plumed pink (*Dianthus plumarius*) at the lower-left corner of the portrait, the traditional symbol of betrothal or marital bliss. The artist has produced an inspired synthesis of floral symbolism.

AM

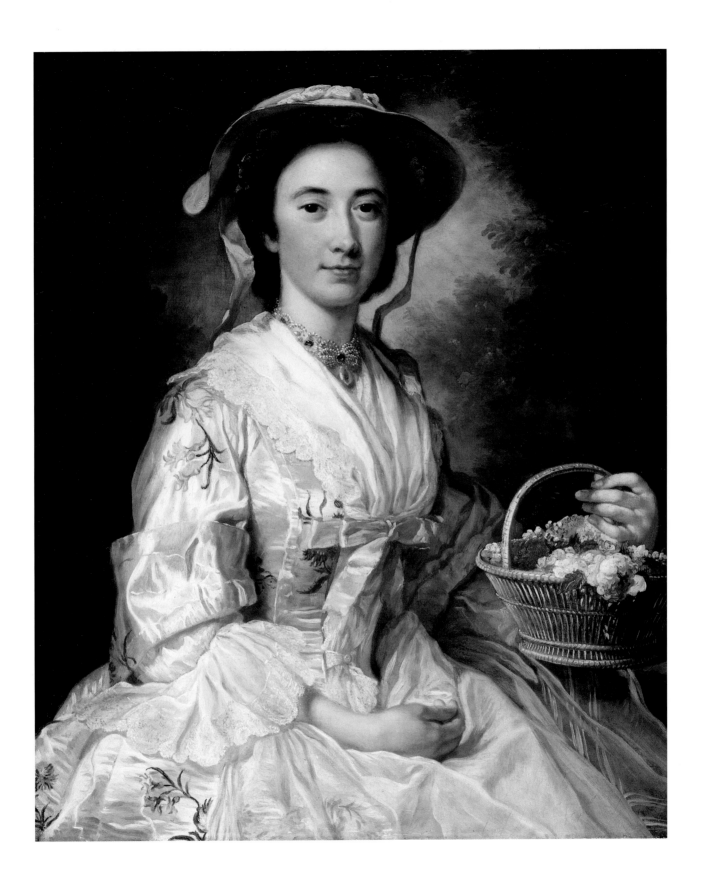

Tureen, cover and stand, c. 1795

Derby, decoration attributed to William Billingsley (1758–1828) or William 'Quaker' Pegg (1775–1851)

Soft paste porcelain, Tureen 31.1 x 45.7 x 25.1 cm; Stand 41.3 x 28.6 cm

Victoria and Albert Museum, London

The precise naming of the flowers under the cover, tureen and stand of this striking piece of Derby porcelain shows the fashion for the study of botany and the extensive influence of contemporary scientific botanical classification on eighteenth-century porcelain decorators. It is known that volumes 1 to 20 of *Curtis's Botanical Journal* were available at the Derby factory from 1792.

The high quality of the botanical decoration of this tureen and the clear similarity between its decoration and some of his sketches have led to it being traditionally attributed to the mature years of William 'Quaker' Pegg (see Anna Pavord, introduction). In spite of his religious scruples, Pegg was forced by financial necessity to return to the Derby factory in 1813. The flower painting of his later career displays a confidence in its use of colour and virtuosity that place him among the very best of the decorators working at the factory. Stylistic comparison with similar Derby pieces of the same period, particularly a comport from the Castle Howard Collection closely following a design inscribed *by Billingsley*, in fact seem to suggest an alternative decorator, William Billingsley, as a more likely candidate although two similar dishes with almost identical flower painting, one given to Pegg and the other to Billingsley in the Charles Norman Collection show that any attribution is far from simple.

In the case of the Castle Howard comport the flowers – *Tulip & Lilac* and *Borage & Crown Pea* – were taken from *A Collection of Flowers* by John Edwards, published in London (1783–97) (John Murdoch and John Twitchett, *Painters and the Derby China Works*, London 1987, 49). However, Billingsley was a skilled botanical artist and seems in many cases, unlike others working at Derby, to have drawn his inspiration directly from gardens and hedgerows rather than copying secondary sources (Murdoch and Twichett p.35).

Billingsley adopted an innovative manner of painting flowers which was to prove extremely influential with other porcelain painters. Rather than leaving patches of undecorated porcelain to create strongly stylised high-lights on the flower as had been customary, Billingsley developed a more naturalistic technique of brushing out his colour to create a light ground to which darker pigment could be added to create tonal variation. CG

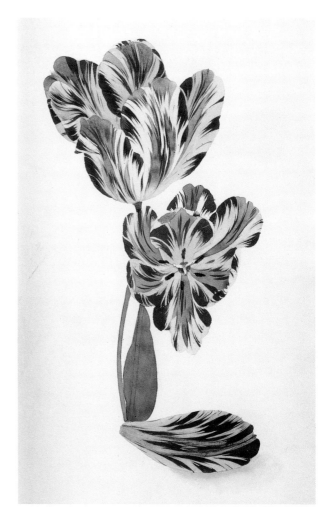

William Pegg, *Tulip*, watercolour on paper, c. 1813

58

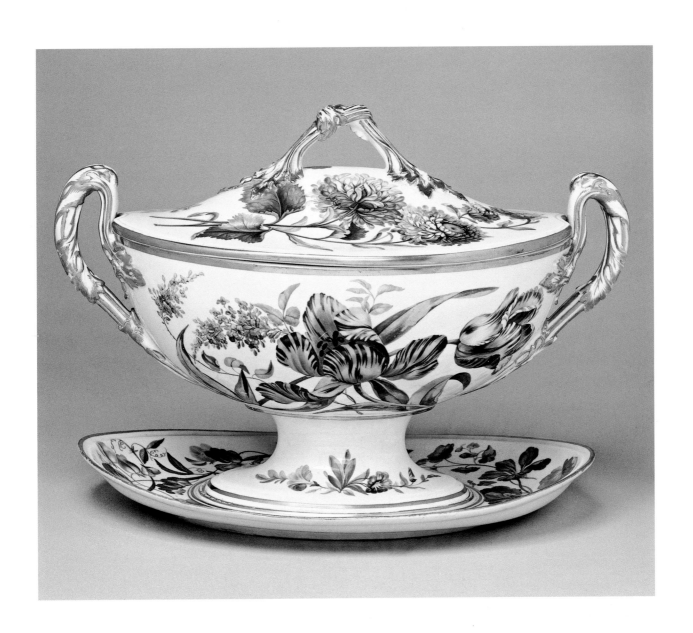

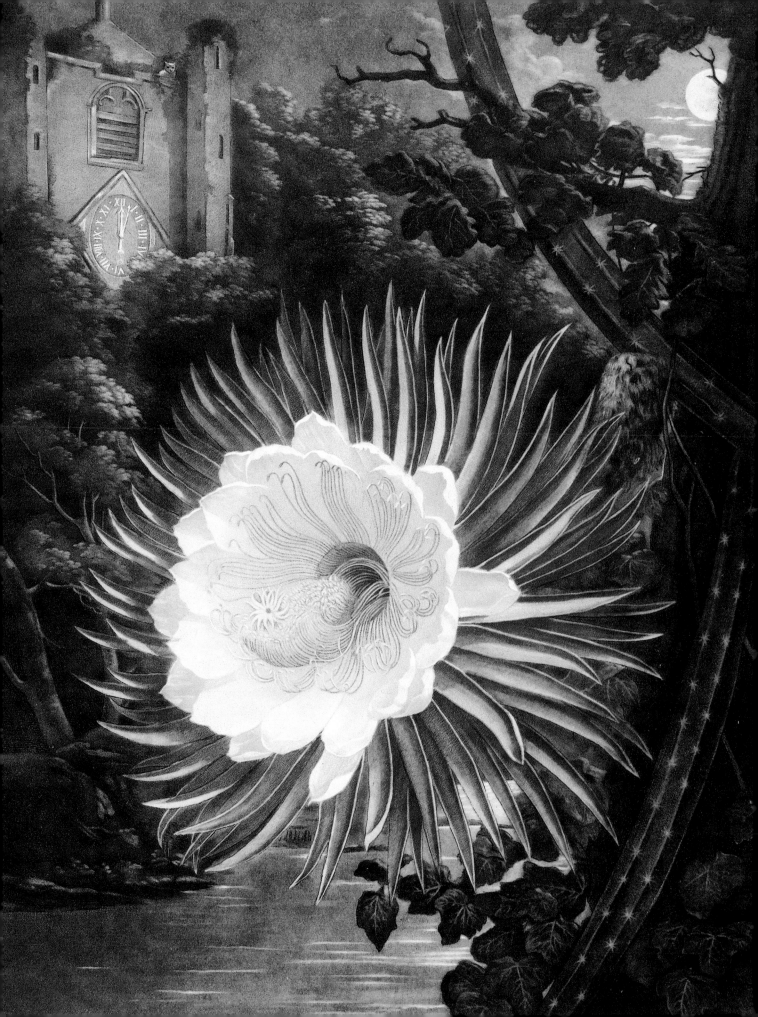

The Night–blowing Cereus
(Selenicereus grandiflorus)

Print after Philip Reinagle (1749–1833)

43 x 30 cm

From 'The Temple of Flora', 1799–1807

Robert Thornton (?1768–1837)
The Provost and Fellows of Eton College

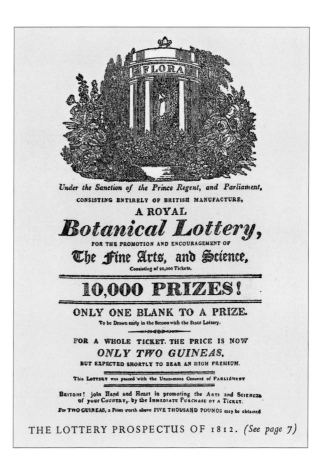

THE LOTTERY PROSPECTUS OF 1812. (See page 7)

The story of Robert Thornton's 'The Temple of Flora' is one of the most fascinating tales within the history of botanical illustration. It was a huge and costly venture, spurred on by personal ambition and Romantic sensibility, which was ultimately the ruin of its founder. Nevertheless, it remains one of the most celebrated of English florilegia.

In 1797, Thornton inherited his family fortune and promptly left his medical practice to pursue his childhood love of botany. He decided to publish a botanical book – one that would surpass all others in the field. A three-volume publication was planned, entitled 'The Temple of Flora, or Garden of Nature; Picturesque Botanical Plates of the new Illustration of the Sexual System of Linnaeus'. The first two volumes would be text, the third was to contain lavish illustrations. Thornton gathered a team of artists, only two of whom, Sydenham James and James Sowerby, were actually botanical artists. The majority of the work was to be done by Philip Reinagle and Peter Henderson, artists chiefly known for their portraiture. A further team of print makers would transform the paintings these artists made into plates for printing. A bewildering array of print techniques was employed – almost every process available – and each plate was finished by hand in watercolour.

The plate shown here, the *Night-blowing Cereus*, is a prime example of the work produced. In his 'Explanation of the Picturesque Plates' Thornton explained that 'Each scenery is appropriate to the subject' (Blunt, 237). In a botanical publication one would perhaps expect this to mean the plants were shown in their natural habitat, but Thornton had other ideas. Suffused with the Romantic spirit of the age (he describes the flowers as 'Beauties of the Vegetable Race'), Thornton requested that each plant be shown in a setting that enhanced its character. In this plate the exuberant desert flower is shown against a gothic English background with a clock showing midnight. In reality, the flower blooms only for one night and in the Victorian Language of Flowers came to signify transient beauty (*Collier's Cyclopedia of Commercial and Social Information*, compiled Nugent Robinson, P.F. Collier, 1882), a highly Romantic and gothic concept. Scientifically, this is a bizarre interpretation of the plant, but visually the effect is striking. The flower dominates the foreground, placed against the setting in a highly theatrical manner, which really does seem to magnify the 'personality' of the plant.

Sadly the public failed to share Thornton's enthusiasm and the book failed to pick up subscribers. A gallery of the oil paintings on New Bond Street (1804) and even the 'Royal Botanic Lottery' (1811), with the Prince Regent as Patron and editions of 'The Temple of Flora' as prizes, failed to encourage sales. The Lottery was finally drawn in 1813, but by this time Thornton was ruined – he had been subsidizing the project for sixteen years. The praise with which 'The Temple of Flora' is now greeted came too late.

JK

Papaver Somniferum
The Opium Poppy, 18 October 1776

Mary Delany (1700–1788)

Bulstrode, Buckinghamshire

Paper collage with watercolour, 29.1 x 17.7cm

The British Museum, London

Mrs Mary Delany's botanical paper collages, or 'paper mosaicks', as she referred to them, demonstrate that she shared the contemporary preoccupation with recording anatomically accurate floral specimens. They show a highly developed skill in the art of paper cutting as well as a strong compositional sense in terms of both colour and perspective. That skill at achieving depth in her work is particularly evident here in the rendition of the broad leaf of the poppy as it curls around the stem. Mrs Delany's desire to render an accurate botanical study is reinforced by the fact that she has recorded the three principal stages of the life cycle of the flower (bud, mature flower and seed pod) in this single study.

Mary Delany recorded on each work its botanical classification according to the Linnaean sexual system. This study, for example, is recorded on the reverse as 'Polyandria Monogynia'. Finally, Mary Delany would record the date of the composition and sometimes the name of the donor of the original botanical specimen or an occasional social note regarding visitors. This detail is particularly revealing, especially as she was often recording flowers that were being newly introduced into the country, specimens she received through her many contacts among the senior botanists of the day.

A skilled needlewoman who had produced some exceptionally fine floral embroidery, Mrs Delany first developed her collage technique in 1772 under the encouragement of her great friend and mentor Margaret Bentinck, Duchess of Portland. She excelled in cutting tiny pieces of different coloured papers and sticking them on a black paper background, which she would then enhance by adding touches of watercolour. It was in the Duchess of Portland's house at Bulstrode in Buckinghamshire that the majority of the flower studies were completed.

Her friendship with the Duchess of Portland was important for a number of reasons. Firstly, it had been the Duchess who had commissioned the work of Ehret (1708–70) – one of the greatest botanical artists of his time – which Mrs Delany would certainly have seen at Bulstrode. It also brought her into contact with George III and Queen Charlotte, a friendship she was to enjoy to the end of her life. Both the king and queen were keen botanists and it was through them that Mrs Delany received large numbers of specimens from Kew. Mary Delany would create nearly a thousand collages before failing eyesight forced her to stop in 1782 (Ruth Hayden, *Mrs Delany, Her life and her flowers*, London 1980). CG

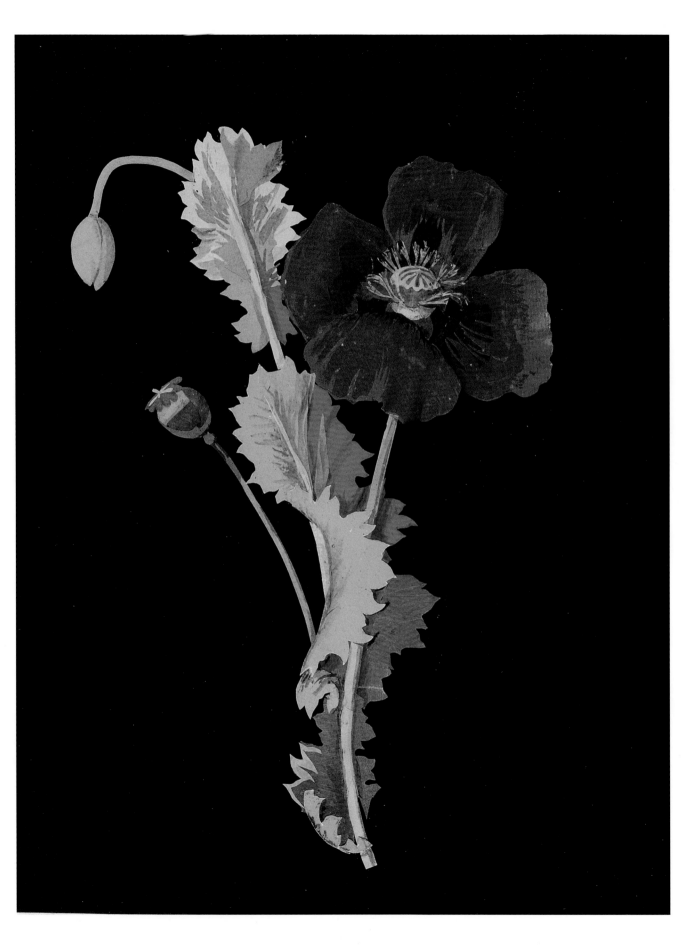

Love and Death

Some of the most deep-rooted flower symbolism finds its origins in myths and legends that celebrate love and commemorate death. An early celebratory use of flowers in both art and life can be seen in the Greek myth that tells the story of Pausius and Glycera. Pliny relates how Pausius, a famous Greek artist, fell in love with Glycera, the inventor of flower wreaths, and created a highly prized painting of her plaiting flowers (Pliny, *Naturalis Historia*, XXXV, 111, 123–27). This story is recounted by Karel van Mander in his *Foundations of the Noble Free Art of Painting* (1604), in a chapter 'On the Distribution and Interaction of Colours', which begins with a defence of the art of flower painting as a celebration of naturalistic painting. We see celebratory garlands recur in Western art and life in honour of Christian themes, notably in marriage ceremonies and also as wreaths of remembrance.

Another key theme in the history of painting is that of *vanitas*, an idea that has not traditionally extended to the decorative arts. Flowers join other symbols of the fleetness of time in *vanitas* paintings that emphasize the transient nature of earthly possessions. While an hourglass or guttering candle may allude to the inexorable passage of time in this life, flowers bearing dewdrops draw attention to the comparative shortness of their lifespan. Thus paintings that might appear to celebrate the wealth of the patron by displaying numerous rare species could equally be intended to represent the fragile nature of such earthly possessions, reminding us of the dangers of arrogance and pride.

The flowers associated with celebration are chiefly the hyacinth, the camellia and the rose. The hyacinth originates from the Orient, being imported to Europe in the mid sixteenth century. The story of Hyacinthus of Sparta, loved by both Apollo and Zephyrus, who made Apollo's discus strike Hyacinthus and cause his death, may seem a strange origin for celebration. However, from the drops of his blood Apollo enabled Hyacinthus to be reborn each spring as a flower. In another legend Hymen, the god of marriage, scattered crocuses and hyacinths on the marriage bed of the gods Zeus and Hera, the origin of the hyacinth's use as a wedding flower in Renaissance Italy (Heilmeyer, 32).

The camellia was introduced from Asia into Europe in 1739 by the Bohemian missionary Georg Joseph Kamell, after whom the flower was named. In Japan the camellia celebrates friendship, grace and harmony, although for the Samurai it symbolized death and the transience of life. The elegant camellia was immortalized in Alexandre Dumas's novel *La Dame aux Camelias* and became one of the most fashionable of flowers in the nineteenth century, a prized element in a bridal bouquet (Heilmeyer, 42). The rose is a further example of a flower whose meaning through the centuries has changed, developing from an emblem of the Virgin in the medieval period to a celebration of love and peace. Other flowers which are associated with love are the anenome, carnation, honeysuckle, lily of the valley, love-in-a-mist, myrtle, pomegranate, poppy, rosemary and even the thistle which, like enduring love, continues to grow in the stoniest of ground. (Heilmeyer, 95). AM

Lydia Dwight Dead, salt-glazed stoneware, 1674 (detail)

Queen Mary of Modena (1658–1718) c. 1673–74

Sir Peter Lely (1618–80)

Oil on canvas, 126.4 x 102.9 cm

English Heritage (Kenwood, The Iveagh Bequest)

The daughter of Alfonso d'Este IV, Duke of Modena, Mary Beatrice was married in September 1673 to James, Duke of York, later James II. The marriage was the cause of considerable concern in England that papal influence was at work. Pope Clement X had indeed advised Mary that this marriage for the sake of two nations was a personal sacrifice that was greater than her childhood wish to become a nun. She is shown in a context that is typical of many portraits of this period, insofar as she is directly engaged with flower symbolism. She is picking orange blossom with her right hand from a plant growing in an urn at her side, while cupping a cutting in her left hand at her side.

The fragrant white flowers and evergreen leaves of the orange bush (*Citrus limon*) have long symbolized purity, innocence and virtue, suggesting eternal youth and entry into paradise.

As such they became the accoutrements of choice for a bride, and this is precisely the moment that Lely is celebrating in his portrait of Mary of Modena. The portrait also serves as a propaganda statement, heralding her innocence and marital fidelity.

Mary was to be painted in the context of flower symbolism again a few years later, c. 1677, this time by Simon Verelst. In that portrait she is depicted holding a bloom close to her womb in a gesture that at the time symbolized pregnancy (Yale Center for British Art). She underwent four pregnancies during the the years 1675–80, a time when sadness entered her life, as only two of her children survived for more than a year. The fresh blooms of the citrus bush record a happier moment for the young Duchess (C. MacLeod and J. M. Alexander, *Painted Ladies, Women at the Court of Charles II*, National Portrait Gallery 2001, 158–61). AM

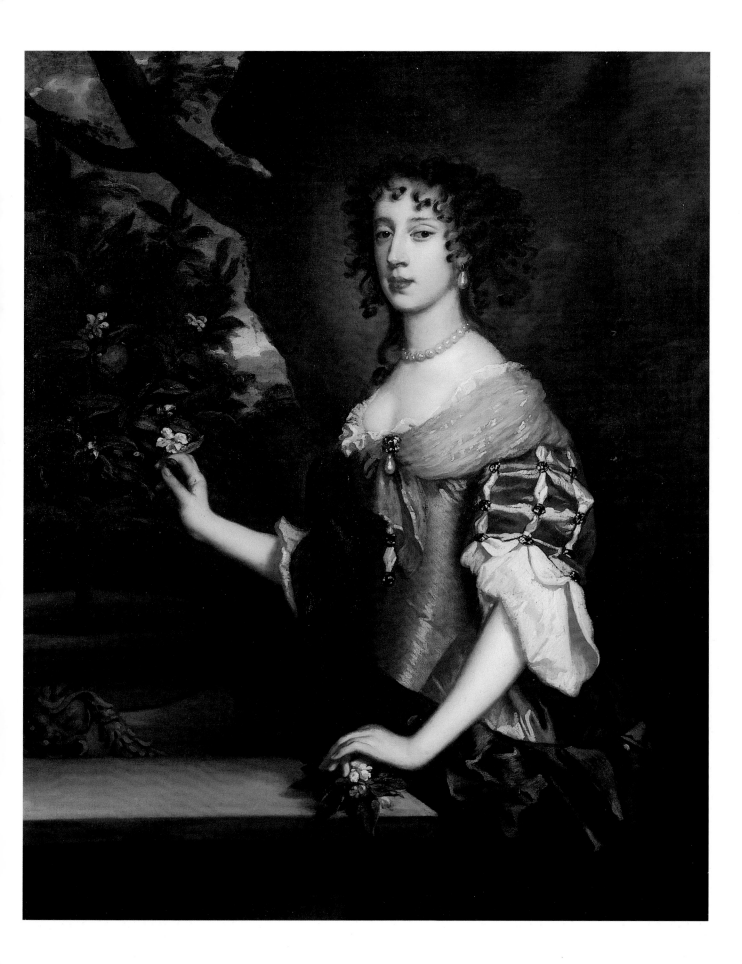

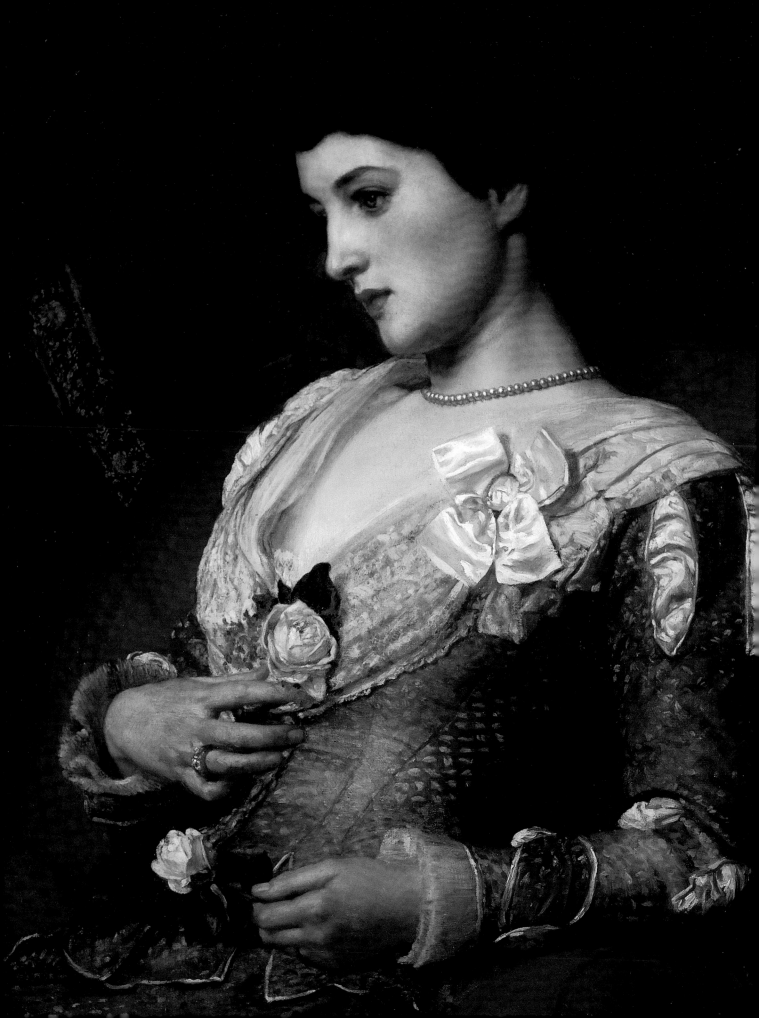

Mrs Langtry, 1877

Sir Edward Poynter (1836–1919)

Oil on canvas, 76 x 66 cm

Courtesy of the Jersey Heritage Trust

Sir Edward Poynter is best known for his neo-classical, heroic scenes in the manner of Frederick Leighton. His long and successful career culminated in the Directorship of the National Gallery (1894–1904) during which time he oversaw the opening of the new Tate Gallery. Poynter also had bohemian links: he was friends with Whistler and related to Edward Burne-Jones through marriage and it was probably through these artists that he met Lillie Langtry.

Lillie Langtry was one of the most famous women of her age. Born in Jersey in 1853, she arrived in London in 1876 recovering from a rather unglamorous bout of typhoid. Despite this inauspicious beginning, she rapidly became the darling of society, and in particular of Oscar Wilde and those associated with the Aesthetic movement. A visitor to Wilde's apartment at 13 Salisbury Street in 1879 described how the room: 'was done entirely in white panelling…there was blue china, and lilies everywhere. Edward Poynter's portrait of Lillie Langtry stood on an easel at one end like an altar' (R. Ellman, *Oscar Wilde*, London 1987, 105), indicating the high esteem in which she was held by Wilde. Poynter had in fact given

the picture to Lillie after it was exhibited at Burlington House in 1877; perhaps it was on loan to the adoring Wilde. Certainly, it seems to have been one of her favourite portraits, as she kept it until her death (L. Langtry, *The Days I Knew*, London 1925, 57).

Poynter has created a highly sensuous portrait, combining Lillie's natural beauty with rich fabrics and flowers. Lillie holds a yellow and a white rose and it is their inclusion that alerts us to the possible meaning behind the picture. It was in the year 1877 that Lillie became the mistress of the Prince of Wales. In the Victorian language of flowers, the rose had specific meanings – a yellow rose signified jealous love (Friend, 451) or adultery, while a white rose suggested silence (Friend, 212) or pure love. Lillie holds the yellow rose to her heart, while the white rose is held away in her left hand. Her wedding ring is barely noticeable. Edward Langtry does seem to have accepted his wife's unfaithfulness and so the portrait might be read as a comment on the current marital situation. The yellow rose stands for Lillie's adultery and the white for her discarded marriage and her husband's silence. JK

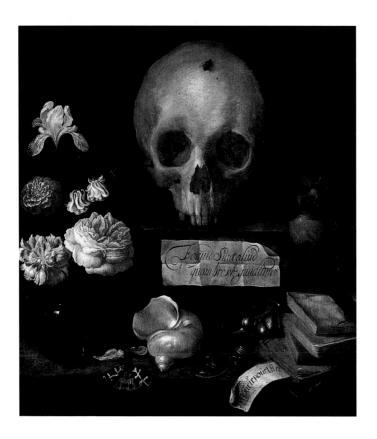

Vanitas Still Life with a vase of flowers, 1636

Adriaen van Nieulandt (1587–1658)

Oil on panel, 40 x 37.2 cm

Frans Hals Museum, Haarlem

The *vanitas* or *memento mori* element so often associated with still-life painting in Holland in the seventeenth century is here given full expression. These associations are made manifest by the central place in the composition of the skull and the bone. Other reminders of death are also evident, notably the fly and Garden Tiger Moth – whose lives are so short – and the worldly riches represented by the coins and exotic shells.

This remarkable image features five carefully executed flowers in a glass vase, readily identifiable as two roses, a carnation (*Dianthus caryaphyllus*), a columbine (*Aquilegia vulgaris*) and an iris. This combination of flowers very clearly reinforces the traditional associations with *memento mori*. While the carnation and columbine both refer to Christ's Passion and the hope for eternal life, the iris is an emblem of faith and purity; the roses refer to both the enjoyment of life and to death. The emblems all invite contemplation of the text on the unfolded paper: 'Ecquid sunt aliud/quam brevi gaudium' – 'is there any pleasure which is not brief?' The text on the bookmark refers in a similar way to the thoughts raised by the cut flowers: 'Mourir pour vivre' – 'die in order to live'. The books allude to the learning that is encompassed in this idea.

The *vanitas* still life eloquently encouraged the onlooker to contemplate the transitory nature of life and death, and to encourage virtue in the process. Allusions to death and mortality were not considered inappropriate, but a cause for celebration. The rose at this period in European society was strongly associated with thoughts of mortality: in his *Iconologia* (1593) Cesare Ripa wrote: 'The rose is a symbol of our fragile nature…. And very correctly is our life compared to a rose, which is truly beautiful and pleasant, yet withers and fades in the same day'. Ripa also writes of glassware in these terms: 'Truly are mankind's hopes a fragile glass, and life is therefore also short'.

Van Nieulandt's composition incorporates a strong 'death's head' approach to his theme, appropriate to the contemplation of life's vanities. The artist was almost certainly influenced by a contemporary engraving of a skull, bone and unfolded paper with text, by Jan Saenredam after a similar, earlier painting by Abraham Bloemaert (B. Haak, *The Golden Age Dutch Painters of the Seventeenth Century*, London 1984, 126, 127). AM

Lydia Dwight Dead, 1674

Salt-glazed stoneware, 25.5 x 20.5 x 11 cm

Victoria & Albert Museum, London

Lydia Dwight died in 1674, aged six. This remarkably personal and intensely moving depiction of a dead child shows her dressed in lace-edged burial clothes and holding a posy of spring flowers that includes tulips. These flowers are a symbol of life but also of the impermanence of life; the posy creates a link between the two worlds of life and death.

The bust of Lydia is hand-modelled in fine grey salt-glazed stoneware. It was made in London at the Fulham pottery of her father, John Dwight, and is incised in the clay, 'Lydia Dwight dyed March 3 1673' (1674 by the modern calendar). Dwight employed artist-modellers, one of whom made the bust of his dead daughter. *Lydia*, and other modelled work, was unknown and remained with the family until 1859 (M. Bimson, 'John Dwight', in *Transactions of the English Ceramic Circle 5*, no.2, 1961, 95–109).

In contrast to our own times, most people living in the seventeenth century experienced the death of greater numbers of children, the wider family and acquaintances. Death shaped the cultural consciousness of the age; it had a collective resonance and a universal significance: every man and woman understood that one day they would die. It is now accepted that love, pain and grief at the death of infants was a deeply rooted and common experience. As the preacher James Cole wrote in 1629, 'We bewail our children, as fruits not yet ripe, too soon plucked from the tree' (David Cressy, *Birth, marriage, and death: ritual, religion, and the life-cycle in Tudor & Stuart England*, Oxford 1999, 343).

Although *Lydia* is an expression of personal grief, she represents a symbolic commemoration for the death of a child that has wider cultural and social connotations. A belief in an afterlife provided comfort much more widely than it does in our society today (Bruce Gordon and Peter Marshall, *The Place of the Dead: Death and Remembrance*

in late Medieval and early Modern Europe, Cambridge 2000, 1–14). Another figure of Lydia, made in the same year, is a more conventional social expression of collective religious belief, of the hopes and fears of the living. Lydia is shown standing, a representation of her resurrection and her triumph over death. Her burial shroud hangs loosely around her, and flowers (symbols of earthly life) lie scattered around her feet, next to a skull that reminds us of her death and subsequent triumph over its aweful and ultimate power.

Lydia is the most intimate of these figures, its individualisation making it the most personally resonant to us today. In Ovid's *Metamorphoses*, many of the transformations visited on mortals by the gods are wrought through flowers. Persephone, the much-loved daughter of the goddess Demeter, was gathering flowers in a field when she was abducted by Hades, the god of the Underworld, and taken to be his queen. The picking of flowers metaphorically marked her violent passage from one world to another; like Lydia, she underwent a 'death' with the loss of her innocence and childhood. DC

A vase of lilac with other flowers on a marble shelf, 1796

Peter Faes (1750–1814)

Oil on canvas, 61.5 x 48 cm

The Bowes Museum, Barnard Castle

The painting of a classical urn filled with lilac blooms on a marble shelf with a selection of other flowers would seem at first sight to be purely decorative and a fairly standard rendition of the genre. However, on closer inspection there is in fact a subtle but strong element of commemoration. The presence of lilac, a traditional flower of mourning, alerts us immediately to this theme and a direct allusion to death can be seen in the fact that one of the stems has been broken.

The urn is identifiable as a vase, shape No. 40, produced by Josiah Wedgwood in both white bisque and coloured Jasper. Although the colour is fairly muted it is possible that the vase painted by Faes is intended to represent a piece made of Wedgwood's lilac-coloured Jasper. In December 1777 Wedgwood wrote to his business partner Bentley that he was able to offer 'green – yellow – lalock [lilac] - &c' although no vases were available before 1780. (Robin Reilly, *Wedgwood*, 2 Volumes, London 1989, 534). No vase of this form in lilac jasper by Wedgwood is known although a garniture of three vases in almost identical shape made in light blue Jasper by Turner is in the collections of the Victoria and Albert Museum (V&A 1474-1855).

The fact that this vase is an identifiable design by Wedgwood also enables us to identify the bas-relief figures in the oval reserve on its side. It is a scene described by Wedgwood in his 1773 catalogue as number 28, *Sacrifice to Aesculapius*, who was killed by Apollo for calling the dead back to life and was reborn as the god of medicine. A vase of very similar form to this was designed by Robert Adam, adapted from an etching in *Raccolta di Vasi Diversi* by Stefano della Bella published in Paris in 1646.

The theme of the roundel, together with the presence of lilac (purple was traditionally worn in the second year of formal mourning), makes the funereal and memorial theme of this painting explicit. Forget-me-nots are also prominently displayed among the other flowers and it is interesting to note that it was painted in 1796, the year after Wedgwood's own death on 3 January 1795.

CG

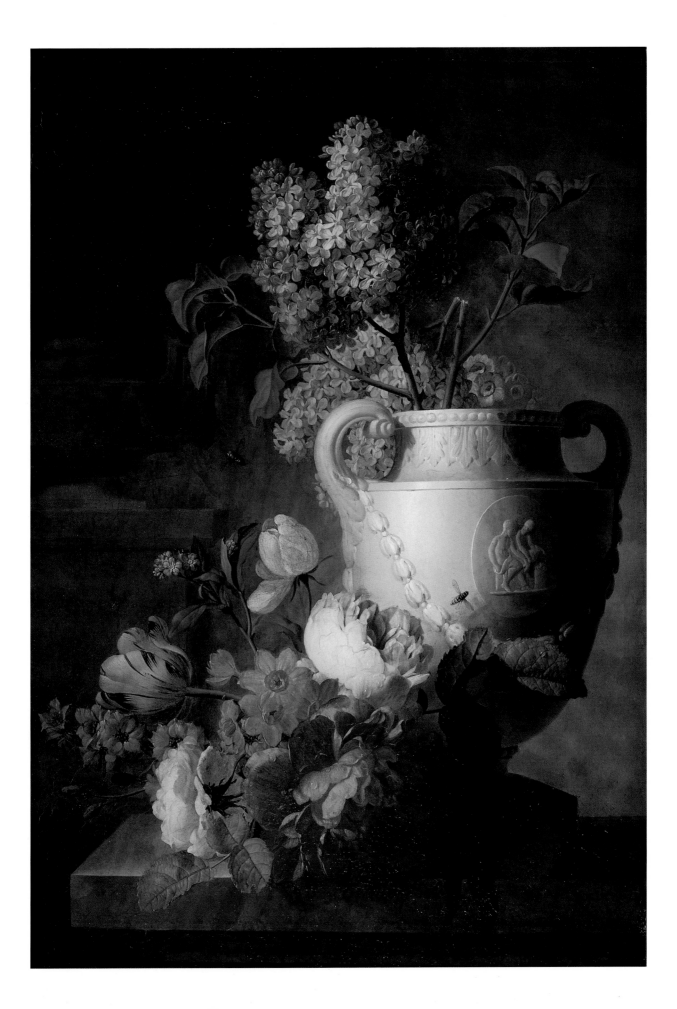

6

Cut and Still – The Decorative Flower

As we have seen, an apparently simple still life of a rose on a silver plate can convey deep religious significance when its symbolism is properly understood. The satisfaction of a balanced composition can reveal more subtle meanings through the language of flowers; branches of lilac in a vase, for example, at first sight might seem purely decorative but closer inspection unlocks carefully selected allusions to remembrance and death.

Having examined the extraordinary symbolic power and strength of flowers to represent profound religious, cultural and scientific truths, it has to be said that in some instances a rose is still just a rose. The purely decorative power of flowers, the sensuousness of their blooms, the sheer exuberant luxury of a flower painting in the hands of artists such as Monnoyer or Van Huysum possess a strength that ensures their influence goes well beyond the picture gallery. Cabinetmakers reinterpret their work in marquetry, while inlaid panels of slate and mother-of-pearl reproduce Dutch flower paintings with equal flamboyance, as do delftware tin glazed tiles. Porcelain manufacturers and embroiderers here represent the many skilled craft practitioners who adapt, adopt and sometimes even improve the flower-painter's art. It is sometimes in this very virtuosity, in the extraordinary level of artifice, in the accomplishment and skill of the craftsman – whether a painter of canvas or of porcelain – that the power of the work exists.

Who could fail to be impressed by the skill that produced the intricate flower panels on Dutch marquetry cabinet? The pleasure of capturing a transient bloom and immortalising it through artifice makes flowers a uniquely powerful source of imagery across both the fine and decorative arts. The concept of a frozen moment in time is never far away, representing a momentary pause in the otherwise inexorable decay that results from cutting a bloom and putting it in a vase. The death in life that cut flowers represent makes them powerfully evocative of atmosphere: the dynamic baroque movement of Monnoyer's *Vase of Flowers* contrasts sharply with the stillness and serenity of roses to be found in the work of Fantin-Latour.

Even at the height of Rococo decorative frivolity in the mid-1730s the subject of a vase of flowers at the hands of an accomplished artist like Jan van Huysum remains grounded in a closely observed realism and can carry traditional overtones of *vanitas*. Butterflies, sometimes symbolising the human soul, are here seen with a caterpillar emphasising the different stages of life from birth and death to resurrection, the last of which is also represented by the traditional symbol of birds' eggs. This may also be an allusion that lies behind the choice of fruits in a still life: black and white grapes and apples being the most traditional of Christian symbols. Decorative flamboyance in the rendering of flowers does not necessarily exclude their power to move or the contextual importance of the tradition in which they were created. CG

Anemones in a Cornish Window, 1930, Christopher Wood (detail)

A Vase of Flowers

Jean Baptiste Monnoyer, called Baptiste (1636–99)

Oil on canvas, 153 x 113 cm

By kind permission of the Duke of Buccleuch and Queensberry, KT

This extraordinary composition was one of a set of four sumptuous flowerpieces ordered from the specialist flower painter Jean Baptiste Monnoyer by Ralph, 1st Duke of Montagu. The 1st Duke had brought Baptiste, a Huguenot, from France in 1690 and by the end of the artist's association with Montagu House he had been commissioned to paint over thirty such paintings. The fashion for Baptiste's works spread to other great houses, notably Burghley, Stourhead and Dyrham. He also worked at Burlington House for Charles Howard, 3rd Earl of Carlisle, and at Kensington Palace. The connoisseur and collector Dézallier d'Argenville wrote of Monnoyer: 'His reputation has spread throughout Europe, and this led to his being chosen by Milord Montagu to journey to England in order to embellish the grand salon, staircase and living quarters of his home with floral and fruit decoration. I have seen this work for myself and it is indeed worthy of Baptiste Monnoyer, who it can be said to have surpassed even himself...' (*Abrégé de la vie des plus fameux peintres*, iv, Paris 1712).

The painting is one of a series which remain in their orginal frames carved by the Huguenot family of carvers and gilders. These feature husk-, flower- and leaf-moulding with added acanthus leaf, flower and strapwork ornament. This treatment is a reminder of the decorative intention behind the commission, but it is also the case that Monnoyer's work was admired for more than purely decorative reasons. The flowers represented are a splendid array of species, demonstrating varieties in a manner that is ebullient and rich in intention, rather than emphasizing botanical accuracy. Nevertheless, the flowers are accurately rendered and this was the key to Monnoyer's success with British patrons, who considered his paintings so lifelike that they lacked only the flowers' perfume. In reality his paintings were the product of a series of drawings and did not reflect the seasons.

This magnificent urn contains an explosion of species which is rather fanciful, with added details such as waves in leaves which are not botanically accurate but achieve artistic effect. Flowers which may be identifiable include lilac, parrot tulips, roses, orange blossoms, and marigolds, with a splendid imperial fritillary (*Fritillaria imperialis*) at its centre. The latter is also known as the Crown Imperial, a name given to it by the physician to the Duke of Tuscany. This majestic flower was the province of high society, symbolizing pride and prestige. The botanist Carolus Clusius had imported this extraordinary flower to Vienna in 1576, later cultivating it at Leiden. Other flowers that can be identified are the peony (*Paeonia*), traditionally associated with paradise and the narcissus anemone (*Anemone narcissiflora*), the flower that reminds us of the brevity of youth (Heilmeyer, 22).

In this case these flowers are less symbolic in terms of emblematic meaning, but certainly exemplify the wealth and taste of the patron. The loose handling of the paint is very different from the precision of contemporary Dutch painters, and typifies the French response to floral decoration that was to remain essentially decorative by comparison with the loaded symbolism of the Dutch painters of the previous generation. AM

Cabinet on stand

Attributed to Jan van Mekeren (1658–1733)

Dutch (Amsterdam), 1690–1710

Marquetry of various woods in a carcass of oak, 206 x 172 x 60.5 cm

Victoria and Albert Museum, London

Cabinets on stands were important items of furniture in formal rooms by the middle of the seventeenth century. They were often veneered with exotic materials, such as ebony or tortoiseshell, but marquetry – the creation of patterns or pictures composed of veneers of different woods – allowed a more faithful, detailed rendition of naturalistic floral decoration. The fashion for marquetry decoration on furniture was fed by the import of exotic woods, many of them new to European eyes. The woods were cut in thin veneers and used to compose a 'picture'. They were either used in their natural colours, or stained in bright colours, such as reds, blues and greens. Shading to give a three-dimensional effect was achieved by dipping the edge of the woods in hot sand, and details such as leaf veins were made with finely engraved lines.

The technique of marquetry was particularly prevalent in the Netherlands, where it reached new levels of pictorial virtuosity. Contemporary Dutch flower painting provided the main source of subject matter to demonstrate this technical expertise, and the degree of naturalism that this particular

cabinet demonstrates in its faded state is still breathtaking. The flat surfaces of cabinet doors provided the canvas on which to work this decorative magic. Prints of contemporary flower paintings, such as works by Jean-Baptiste Monnoyer (1636–99), were engraved by the painter or other engravers, and then printed and distributed by publishers. They were used by craftsmen, either as direct sources, or as inspiration for their own designs.

The marquetry decorated surfaces of these cabinet doors are of kingwood, ebony, rosewood, olive, sycamore and other woods. The woods were chosen for their colour or grain, although polish and fading of the original colours has changed the original effect of colour and texture (Sarah Medlam in ed. Christopher Wilk, *Western Furniture, 1350 to the present day*, London 1996, 76). The effect of such cabinets, highly coloured, in a room with richly coloured textile or leather hangings and upholstery, usually with floral ornament, would create a decorative cohesion in which paintings were – to contemporary eyes – only one component of a luxurious whole. DC

Flowers in a Terracotta Vase, 1736–37

Jan Van Huysum (1682–1749)

Oil on canvas, 133.5 x 91.5 cm

National Gallery, London

Jan Van Huysum was the most popular painter of cut flower compositions in Britain in the eighteenth century. Collectors appreciated his ability to transform traditional ideas of transience associated with the still life genre, but preferred his ability to describe flowers with finesse and exuberance. His compositions seemed to cheat death by combining flowers out of season in a single vase. This interpretation of the attraction of his paintings is given visible form here by the signature, which shows how he has taken time to paint his canvas. The pedestal is inscribed with two dates: 1736 and 1737.

This understanding of the artist's working method was well understood in the eighteenth century. Horace Walpole, when confronted by two of van Huysum's paintings in his father's collection, commented: 'highly finished, labour ill bestowed: a flowerpiece of Baptist's (ie Monnoyer) of one week's work, at twelve yards distance will outshine any work of this artist's, yet it is achieved at the expense of a twelve month' (Norfolk Record Office). However, Horace Walpole's typical asperity is misconceived. The idea that the artist was dependent upon the season is not the only explanation of his working method.

Sketches survive which clearly demonstrate the technical process that Van Huysum and his brother, a fellow flower painter, underwent in creating their compositions (British Museum Print Room). In this respect they were following in the tradition of their father. They would make watercolour studies of individual blossoms, less botanical in their accuracy but sharply observed. They also considered the overall compositional scheme and produced free-flowing sketches in chalks and Indian wash. At this stage they would consider motifs such as that of young cherubs cavorting on the surface of a vase or urn, perhaps invoking a classical scene beyond.

The final element was often a bird's nest, snails or insects. They would also produce a watercolour sketch of the composition in order to establish the colour values of a proposed arrangement of flowers. This deliberation was as important to their working process as the practical problem of seeing flowers in bloom: this was the key to Van Huysum's success in achieving apparent spontaneity in his flowerpieces. While *vanitas* elements remain important to flowerpieces such as this, a major part of the appeal of Van Huysum's work is the transcendent quality of his floral bouquets, here on a scale that suggests the painting was designed as an overmantel.

The flowers featured are double-flowered hyacinth (*Hyacinthus orientalis*), narcissus (*Narcissus*), double opium poppy (*Papaver somniferum*), hollyhock (*Alcea rosea*), Xiphium iris, apple blossom, lobelia (*Lobelia*), Florist's auricula, carnation (*Dianthus caraphyllus*), convolvulus (*Convolvulus tricolor*). Other elements in the composition, acknowledging the *vanitas* tradition, are the butterflies – a Red Admiral, Large White and Painted Lady – hovering around the vase. AM

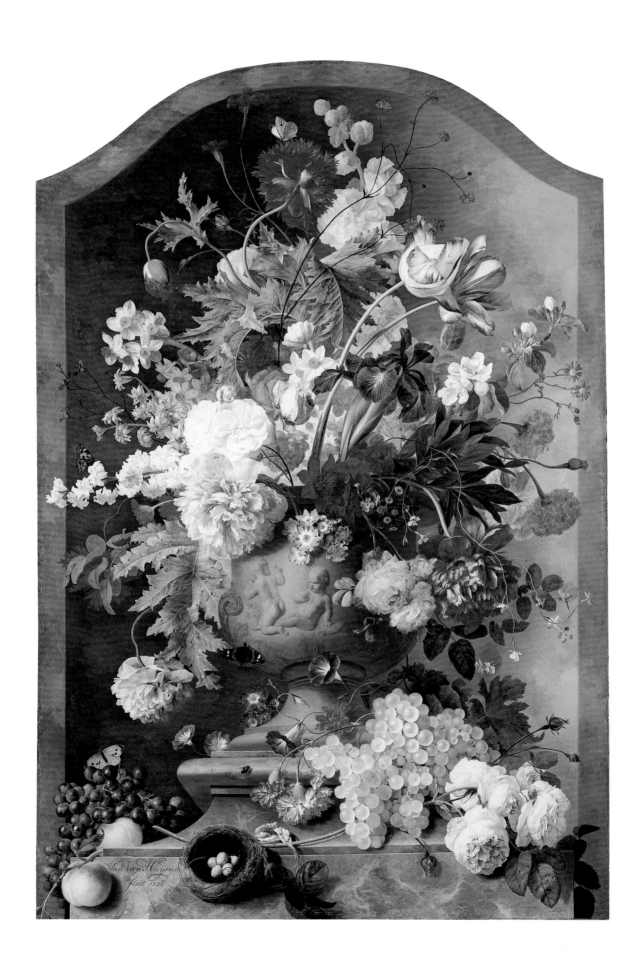

Roses, 1895

Henri Fantin-Latour (1836–1904)

Oil on canvas, 36.5 x 39 cm

National Gallery of Scotland, Edinburgh

The powerful sense of calm, peace and silence suggested by Henri Fantin-Latour's delicately painted study of roses is typical of the atmosphere conveyed by the closely observed realism of his still lives. Justifiably famous for meticulously rendered flower paintings, mostly produced between about 1870 and 1889, they stand in sharp contrast to some of his other work which consisted of large figure subjects and group portraits.

From 1861 Fantin-Latour exhibited regularly at the Paris Salon but in 1863 was included in the Salon des Refusés alongside some of the more avant-garde artists of the period including Manet, Cézanne and Whistler. His style was very much more conservative than theirs and

his flower paintings are firmly grounded in the tradition of seventeenth-century Dutch flower painting with the delicate colour of his roses set against a dark and essentially plain background. Algernon Charles Swinburne described them in a poem entitled *A Flower-Piece by Fantin*:

Deep flowers, with lustre and darkness fraught
From glass that gleams as the chill still seas...

The texture of Fantin-Latour's paint, his use of a loaded brush with short brushstrokes and the sensuousness of his treatment of diffused light as it casts delicate shadows on the petals shows him to have been no slavish copyist of the Dutch. In this sense he had more in common with the Impressionists, many of whom he counted among his friends, than one might at first imagine.

Fantin-Latour is mentioned twice in Proust's *A la Recherche du Temps Perdu* as the benchmark of quality by which other flower painters should be judged. There is a contemplative beauty about this work, a luxurious fullness about each bloom which is immediately satisfying but which also communicates an extraordinarily

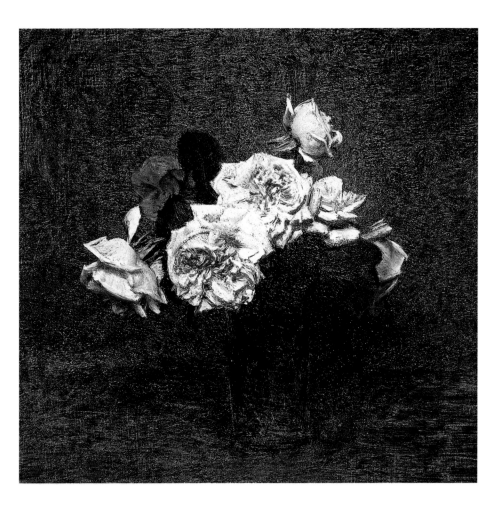

evocative atmosphere, redolent of dust settling in the late summer stillness of a drawing room heavy with the scent of roses. He seems to suggest a quality just before the first petal falls where the flower is at its most perfect. In his preface to *Propos de Peintre* Proust describes Fantin-Latour waiting to catch this specific moment: 'What a turnaround, at the last session, when the end of the day approaches to harmonise and orchestrate the entire work and to introduce vigour and decisive brilliance just before the moment when all the beautiful flesh tones, yesterday still quivering with life, go on to form, withered, nothing more than a charnal house'. Fantin-Latour has arrested the scene at that moment before the notion of death and decay implicit in the cut flowers becomes explicit. CG

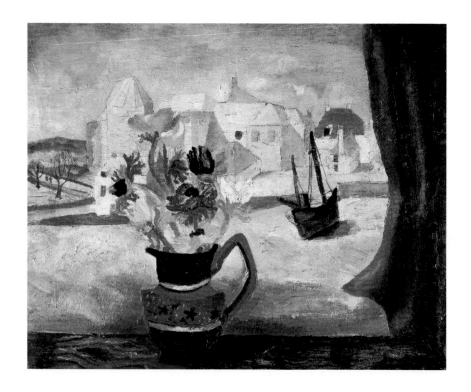

Anemones in a Cornish Window, 1930

Christopher Wood (1901–30)

Oil on canvas, 40.6 x 48.2 cm

Leeds Museums and Galleries (City Art Gallery)

This painting dates from the last year of Christopher Wood's tragically short life. It had been a life divided between France and Britain and one that was often at odds with the freshness and vitality of his art.

Wood was born in Liverpool and studied architecture briefly at the University. By the age of twenty he was in Paris, intimately involved with artistic and social circles and set upon a career to become a 'modern' artist. In 1926 he met the British artists Ben and Winifred Nicholson and joined them as members of the progressive Seven & Five Society of Painters and Sculptors; more significantly he became a close friend and painting partner of the couple, working with them in Cumberland and Cornwall. He and Winifred frequently painted from flower and still life subjects, and at one point she was sending flowers for him through the post to Paris.

In this lyrical still life, Wood has placed his jug of flowers against the traditional device of the window frame, but the convention is given new life by the freshness of vision and assured composition. Anemones, with their jewel-like colours, soft undulating foliage and expressive contours, were the flowers of choice for many artists, but Wood seems to infuse them with a particular poignancy. Acutely sensitive as both a painter and man, it is perhaps not too fanciful to speculate on Wood's decision to feature the flower in this late work given its traditional associations.

The *Anemone coronaria*, or windflower, arrived in Britain during the Crusades in the twelfth century and occurs in many emblem books associated with the phrase 'Brevis et usus' (Campbell-Culver, 58). The anemone's early association with Christ's Passion, and therefore death, the brevity and transience of life, martyrdom, refusal and abandonment gives this painting an emotional charge. In mythology anemones were associated with Aphrodite's sadness at the death of Adonis, springing from his blood as it soaked into the earth. These powerful associations make it difficult to believe that the artist was unaware of the symbolism of his subject (Heilmeyer 94) AG

7

The Power to Move

It is in the artistic practices of artists and makers from the post-war years that we witness the coming of age of the flowerpiece. The enduring appeal of flowers has continued to exercise a powerful spell over a new generation, who in their choice of media are exploiting the immense potential offered by technological advances. Informed by the wealth of historical antecedents, artists have created works that challenge traditional concepts, often proceeding to subvert them and ultimately make a significant and innovative contribution to them.

For this process to succeed – and the best examples do so magnificently – an awareness of past traditions needs to be married to an acknowledgement of, and response to, the emotional power of modern sensibilities. This 'power to move' – ostensibly a modern phenomenon and far removed from the impact of floral anatomical accuracy or commemorative celebration – is in truth the latest chapter in a long romance. As we have seen in previous sections, the symbolism, character and formal possibilities inherent in the iconography of the flowerpiece have fascinated generations of artists, and have been taken up with renewed vigour by the post-war generation. From using imagery as a purely decorative device to depicting the decadence of decay, the range of artists who have taken up the challenge is impressive.

It is also the case that possibly no other period in the twentieth century could have allowed artists such a choice of technical means of expression, and the results have been as diverse as the media employed; this diversity represents a mini-history of post-war artistic practice. In the 1960s and early '70s, for example, the art of printmaking went through something of a renaissance, with new developments particularly in silk-screen printing. Imagery was often closely linked to the Pop Art Movement – with the flower frequently used as a decorative and repeated device – while its symbolic value took on a much wider significance for the new Flowerpower movement, when the flower was associated with love and peace.

In recent decades, an even greater freedom of artistic expression has been made possible through technological advances and these have coincided with shifts in public perceptions of contemporary art and artists. Andy Warhol's famous remark about the transitory nature of fame has taken on new weight with the status of many of today's artists, and it is both refreshing and maybe a little surprising that many have looked to the floral tradition for inspiration. It is when this inspiration translates into innovative and challenging work that the transforming alchemy of art takes place.

Individual artists' preoccupations and experiments inform these transformations: thus chrysanthemums no longer sit in neat bunches or delicately lose their petals but rather float in pools of household detergent. Orchids, once the preserve of the rich and rarefied, become the ultimate embodiment of the vanitas theme portraying the horrors of a contemporary disease which lie so close to surface beauty. The unique qualities of the flower image can now be suspended in time and frozen in silicone permitting a level of intensity of experience which matches that of any previous generation, and which would surely have won the admiration of Dutch seventeenth-century practitioners.

Sex, decay, decadence and death are all subjects ripe for examination in our post-Freudian society; how salutary that the not so humble flowerpiece continues to exert its enduring magic in this company and provide the inspiration for new ways of interpreting that magic and transforming its power to move. AG

Italian Landscape IV, 2000, Marc Quinn (detail)

Flowers, c. 1943

David Bomberg (1890–1957)

Oil on canvas, 91.5 x 61 cm

Norwich Castle Museum & Art Gallery

The power of this image is explained by the circumstances during which it was painted, in Queens Gate Mews in wartime London. In February 1942 Bomberg was commissioned by the War Artists' Committee to paint the Burton-on-Trent bomb store. His commission was not altogether happy. He was transfixed by the sight of the bombs stacked in the disused mines and made numerous paintings of the stores, evidently disturbed yet fascinated by what he witnessed. However, the War Artists' Committee did not especially value his contribution and he was not encouraged to complete his project with a memorial panel as he had anticipated, despite the fact that he had produced what in retrospect are acknowledged as among his finest works.

The artist's wife Lilian suggested that he turn to flower painting as a subject. She bought flowers from a flower seller outside Gloucester Road tube station and after two or three days suggested that Bomberg paint them. At first he refused, but then took to the task with characteristic intensity: Lilian describes how 'he used to go every day early to Covent Garden to buy the flowers himself. He only painted flowers, and very much enjoyed doing it. He always arranged them himself, in the same vase, against the same curtain. He wasn't interested in flower arrangement – he'd just put them in and paint them'. Bomberg produced a series of canvases that celebrate beauty and violence in the flowers, with the result that they almost burst out of their vase.

Bomberg seems to portray destructive forces even as he celebrates the life force within the flowers. The artist Joseph Herman recalled Bomberg saying, in a conversation cut short by the menacing sound of the sirens, 'even flowers can be painted so as to remind us of all the terror in the human breast'. He used a restricted palette, laying his colour thickly onto a course canvas, with a strong brushwork texture, using high impasto. When he

displayed two of these paintings in an exhibition in 1943 a reviewer commented: 'these are veritable explosions in oil colours; No. 25 goes off with an almost audible bang' (Richard Cork, *David Bomberg*, Yale 1987, 248–51). AM

Heralding, 1959

Cedric Morris (1889–1982)

Oil on canvas, 99 x 73.6 cm

Mary-Rose Tatham

The reputations of his more fashionable contemporaries have often overshadowed that of Cedric Morris, but he deserves to be considered as one of the most important and original flower painters in twentieth-century British art. He was an enthusiastic plantsman as well as teacher, whose energies in the garden matched those in the teaching of his pupils. With his partner Lett Haines, Morris established the East Anglia School of Painting and Drawing, first at The Pound in Suffolk in 1937, then in 1940 at Benton End, in nearby Hadleigh. He cultivated flowers in the garden at Benton End overlooking the River Brett, which is seen here in the background to *Heralding*, lending an unusually surreal quality to his composition. For Morris the garden was an essential element in the teaching process, a place where his students could truly study nature.

Morris has created a purposefully symbolic work that features the iris, the flower for which he is best remembered. The flowers herald the coming of summer: the iris (*Iris Orio-cyclus*; *Iris japonica*, *Ledger's* variety and *Iris latofolia*) flowers in May and June, while the alium (*Alium siculum* and *Allium stipitatum*) is also an early summer bloom, as is the yellow plicata. Morris's favourite iris as a grower is included here, the *Iris tectorum*. The plantsman recorded his delight in the iris, describing 'the elegance, pride and delicacy' of the species (Clare Sydney, *Flower Painting*, Oxford 1986, pl. 25).

Morris represents an engagement with plants that forecloses any idea that the flower is simply a decorative motif. John Nash is another example of a plantsman-gardener in East Anglia who illustrated a number of botanical works. At the same time, it is difficult not to feel that Morris is acknowledging the seventeenth-century Dutch flowerpiece tradition with his treatment of this subject. The introduction of a Delftware style blue-and-white vase at the centre of a composition teases the eye as it swirls around the still life. The colour tones are characteristically rendered in an iridescent hue that here reference directly Morris's favourite flower (B. Tufnell, N. Thornton, H. Waters, *Cedric Morris and Lett Haines: Teaching, Art and Life*, Norwich 2002). AM

Lotus I, 1978

Howard Hodgkin (b.1930)

Indian textile dyes on hand made rag paper, 72.5 x 90 cm

Norwich Castle Museum & Art Gallery

Lotus I is one of a pair of images from Howard Hodgkin's *Indian Leaves* series, a richly evocative and brilliantly coloured group of watercolour impressions of India painted during a two-week visit there in 1978. Hodgkin has described the *Indian Leaves* series as 'a kind of sampler of all the different kinds of language I use in my paintings, but used in an almost simplistic way'.

Hodgkin painted the watercolours while staying in Ahmedabad as a guest of the Sarabhai family, millowners with a Le Corbusier house set in a 'Douanier Rousseau' garden. He worked in a white room in a small white bungalow in the garden, where he says 'occasionally they would glance through the window at me, rather like eighteenth-century gentry in England would look at their pet hermit'.

This watercolour draws upon the lotus as an image of so much that is indigenous to India. The circumstances under which the image was conjured onto paper are integral to its powerful impact on the mind's eye and the emotional charge it conveys. The image is large, painted on freshly made, unsized and still-wet rag-paper, using textile dyes, in colours from the locale. The choice of a lotus, albeit in an image of spare and fluid abstraction, is especially fitting. The essentially autobiographical nature of the work is enhanced by the artist's identification with the place and the flower. The lotus is the national flower of India, a symbol of heaven and transcendence in both the Hindu and the Buddhist faith.

The artist has told a story of how much the *Indian Leaves* meant to him: 'Once finished, everything was packed and crated. The crate was put on top of the taxi, and we drove out to the airport – but when we arrived it wasn't there. I was told "It's just a loss you'll have to accept". I cried on the way back to London, thinking of one image and then another....Four months later I had a phone call saying the Bombay police had a parcel of mine, and did I want it? When the parcel arrived in London there were all the works, in perfect condition...'. AM

Bouquet, 2000

Richard Slee (b. 1946)

Handbuilt earthenware ceramic with painted lustres and fabric

bow, 30 x 25 x 60 cm

Collection of the artist

Richard Slee's bouquet of stylised, artificially coloured flowers is in full bloom and was created as a representation of both celebration and bereavement. The clay flowers appear solid and heavy but equally fragile due to the nature of the material in which Slee works. Like much of his work it draws on cultural identity and communal values, comprising recognisable forms that are playful, brightly coloured, and highly glazed. He plays with a sense of the decorative that looks at ornamental traditions, particularly in ceramic history. However, their visual wit and decorative references are juxtaposed by a sense of irony and unsettling resonance.

Flowers have a fleeting life; once they have been cut they begin to die. Frozen in time by the earthenware material in which it has been made, this bouquet transcends decay and death, and is redolent with collective memory (Craftspace Touring, *A Sense of Occasion*, exh. cat., Birmingham 2000, 8, 50).

Traditionally, bouquets of flowers have been given by lovers or carried by brides as a celebration of love and hope for the future. They have also been offered as congratulations. As traditional wreaths have fallen out of favour as expressions of private grief at funerals, the modern bouquet has taken its place. In recent years public events have brought forth intense and universal expressions of sorrow, such as the death of Princess Diana in 1997. Bouquets of flowers were laid as a tribute to her by many thousands outside her London home, Kensington Palace, and thrown in the wake of her funeral cortege. Public empathy with private grief is often visible through the flood of anonymous bouquets that are left in a spontaneously identified location following equally terrible events that are widely reported and now form a part of the collective experience of the modern world. Remembering and commemorating the dead is one of 'the most reflective and past-minded of activities' that 'is in every age a remarkable contemporary testimony' (Bruce Gordon and Peter Marshall, *The Place of the Dead: Death and Remembrance in late Medieval and early Modern Europe*, Cambridge 2000, 16).

The floral bouquet has acquired a new resonance, as a collective token of grief, and it is this quality that Slee has so evocatively invoked with his ceramic flowers.
RW

Italian Landscape IV, 2000

Marc Quinn (b.1964)

Permanent pigment on canvas, 109.8 x 166.4 cm

Jay Jopling/White Cube (London)

'The flowers are dead but they appear to be alive. Immaculate perfection always evokes revolting death to me' (Marc Quinn, Tate Liverpool interview, 2002).

Mark Quinn is one of the most original and controversial of the British artists to have emerged during the 1990s. His work has always shown a preoccupation with the mutability of physical states, which he has interpreted through a variety of media. These have included a sculpture – *Self Portrait* formed from the artist's frozen blood – and challenging, subversive and beautiful marble portraits of the limbless. He brings the same preoccupations to bear on his extensive body of work based on flower and plant life – in Quinn's case the term still life can be defined literally.

The set of ten *Italian Landscapes* are based on photographs taken of his installation *The Garden* (2000) which was commissioned by the Fondazione Prada in Milan. This large-scale work contains an astonishing array of flowers and plants frozen in perpetual bloom by means of silicone. Although based on photographic images, the *Italian Landscape* series have been made by using a form of permanent pigment to fix the image indelibly, thus emphasising and enhancing their state of perfection.

Marc Quinn's work presents a truly contemporary response to the art of seventeenth century Holland. Rich, exotic blooms are juxtaposed in unlikely states of season or environment; their preserved perfection at odds with the immutable fact of their death. They live on as icons: 'just like movie or pop stars who die young. We continue to worship their perfect image, but, for them, it's all over, it's irrelevant' (Marc Quinn, interview with Germano Gelant, Fondazione Prada, 2000). AG

Honeysuckle for St John's, 2002

Zoë Walker (b. 1968)

Photographic transparency on lightbox

61 x 89 x 12.5 cm

Courtesy of Houldsworth, London

Honeysuckle for St John's is part of a series commissioned for the Department of Plastic and Reconstructive Surgery at St John's Hospital, Howden. At first glance it appears to be a simple photograph of a honeysuckle plant. However, the central flower is entirely false. Created by Gill Thomson, Maxillio Facial Technician in the department, it is made from the same silicon and paints used in making prosthetics for patients at the hospital. The series features a number of photographs of the fake flower against real foliate plant backgrounds, and were displayed between wards for patients, visitors and medical staff to see. The flower was shown next to them in a glass case, to prove that part of the work was indeed artificial, as it is almost impossible to tell that the photograph is not of an entirely real flower. Blending seamlessly into the honeysuckle plant, the silicon flower blurs the boundaries between reality and artifice; the natural and unnatural.

This bears an extremely positive message for patients who require a prosthetic. The photograph demonstrates just what is possible and encourages the patients' optimism as to the high standard of any finished results. The choice of honeysuckle is also important. Walker was keen to use a flower that was used in medicine, and honeysuckle has been traditionally valued for its medicinal properties since the beginning of the last millennium.

This approach to honeysuckle is quite different to the emblematic meanings it is often credited with, such as love and lasting pleasure. Dioscorides, the Greek pharmacologist writing in around 30 AD commented that: 'the ripe seed gathered and dried in the shadow and drunk for four days together, doth waste and consume away the hardness of the spleen and removeth wearisomeness, helpeth the shortness and difficulty of breathing...' (quoted in John Gerard's *Herbal, or a General Historie of Plants* 1597). Dioscorides' five-volume *De Materia Medica* contained descriptions of around 600 plants together with their medicinal properties and was considered the most authoritative book on the subject well into the sixteenth and seventeenth centuries. His influence is still detectable today; honeysuckle is commonly used in aromatherapy preparations, mainly for its calming properties. It is used to treat asthmatics ('the shortness and difficulty of breathing') and is often used to treat cancer patients, helping them to relax, an important part of the healing process. Walker's use of it here is therefore relevant and meaningful, providing another element to her highly positive work. JK

Photography Credits & Copyright

Flora's Retinue or *Flora's Train*, set of six relief moulded tiles, designed by Walter Crane in 1901 for Pilkington's Tile and Pottery Company, Victoria and Albert Museum, London

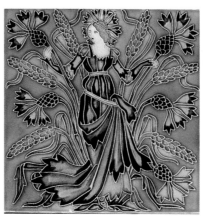
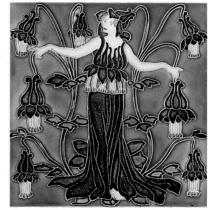

Further Reading

BERGSTÖM, INGVAR, 'Disguised Symbolism in "Madonna' Pictures and Still Life", *Burlington Magazine* 1955

BLUNT, W. and W.T. STEARN, *The Art of Botanical Illustration*, London (new edition) 1995

CAMPBELL-CULVER, M., *The Origin of Plants*, London, 2001

FISHER, CELIA, *The National Gallery: Flowers and Fruit Pocket Guide*, London 1988

FRIEND, HILDERIC, *Flowers and Flower Lore*, 2 vols, London 1883

GOODY, JACK, *The Culture of Flowers*, Cambridge 1993

GREENAWAY, KATE, *The Language of Flowers*, London 1884

HALL, JAMES, *Dictionary of Subjects and Symbols in Art*, London 1974

HEILMEYER, MARINA, *The Language of Flowers, Symbols and Myths*, Munich, London & New York 2001

HULTON, P. and L. SMITH, *Flowers in Art from East and West*, London 1979

KEAR, KATHERINE, *Flower Wisdom*, London 2000

LANGMUIR, ERIKA, *The National Gallery Companion Guide*, London 2001

LEHNER, ERNST and JOHANNA, *Folklore and Symbolism of Flowers, Plants and Trees*, New York 1960

MOLENAAR, YVONNE, *Bloemen Constig geschikt*, Zwolle 1998

PAVORD, ANNA, *The Tulip*, London 1999

RIX, M. and W.T. STEARN, *Redouté's Fairest Flowers*, London 1997

SCOTT-JAMES, A., *The British Museum Book of Flowers*, London 1989

TAYLOR, PAUL, *Dutch Flower Painting 1600-1720*, Yale 1995

TONGIORGI TOMASI, L., *An Oak Spring Flora*, Upperville 1997

WOLDBYE, VIBEKE (Ed.), *Flowers into Art*, exhibition catalogue, The Hague 1991

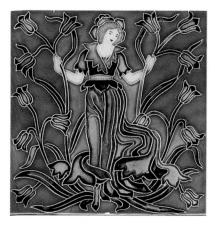 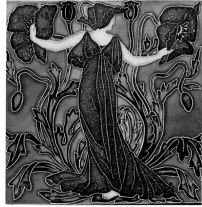

Index